Singular Images
Essays on
Remarkable Photographs

Edited and with an introduction
by Sophie Howarth

Essays by Darsie Alexander, Geoffrey Batchen,
David Campany, Roger Hargreaves,
Sophie Howarth, Liz Jobey, Mary Warner Marien,
Sheena Wagstaff, Nigel Warburton, Val Williams
and Dominic Willsdon

Tate Publishing

First published 2005 by order of the Tate Trustees
by Tate Publishing, a division of Tate Enterprises Ltd,
Millbank, London SW1P 4RG
www.tate.org.uk/publishing

© Tate 2005
Essays by Geoffrey Batchen and Liz Jobey © The authors 2005

British Library Cataloguing in Publication Data
A catalogue record for this book is available from the British Library

ISBN 1 85437 654 3 (pbk)

Design: James Goggin/Practise
Design assistance: Sandra Zellmer

Printed and bound in Singapore

Front cover: Nan Goldin *The Hug, New York City* 1980 (detail)

Contents

Introduction

Sophie Howarth

The idea for this book came from a bet. Beaumont Newhall, former curator of photography at the Museum of Modern Art in New York, recalls the incident in his autobiography *Focus: Memoirs of a Life in Photography* (1993):

> My friend Van Deren Coke is a very good photographer and teacher of photography, and very much interested in the development of modern art. One day he challenged me: he bet me I couldn't talk for one hour about one photograph. I chose one of Stieglitz's most celebrated pictures, *The Steerage* ... very easily spent one hour lecturing on a single photograph and won the bet.

More than thirty years after Coke and Newhall's bet, many people still doubt whether individual photographs can hold our attention to the same extent as paintings or sculptures. This anthology is an enquiry into the value of sustained engagement with single images. As the title suggests, the focus of each essay is on the uniqueness of a particular image, seen from the point of view of production, intention, encounter and interpretation. The book can be read as a collection of stories or as a partial history of photography.

For most of its history, photography has been the subject of intense debate within the art world. Its detractors have insisted that photographs are objective documents unable to serve as vehicles for artistic intention, its defenders that it can be as subjective and expressive as any other art form. One of the most important champions of photography as a fine art was Alfred Stieglitz, not only a photographer but also as a gallerist and publisher of the journals *Camera Notes* (1897–1902) and *Camera Work* (1903–11). As Beaumont Newhall points out, *The Steerage* is one his best-known pictures. It depicts passengers boarding the upper and lower decks of a luxury liner to Europe in 1907, and is often described as a quintessentially modernist

photograph because of the way in which the bridge onto the liner forms a bold diagonal, cutting across the middle of the image to separate the two classes of passenger both formally and symbolically. It is exemplary of what Henri Cartier-Bresson described as the 'decisive moment' in photography: 'the simultaneous recognition, in a fraction of a second, of the significance of an event as well as the precise organisation of forms which gives that event its proper expression'. *The Steerage* speaks volumes about travel, immigration and class in America in the early years of the twentieth century, and having been in circulation for nearly a hundred years has become almost legendary in its own right. It is not hard to imagine Newhall analysing its form and content and relating stories about its reception for at least an hour.

In spite of Stieglitz's best efforts, it was not until the demise of modernism that photography finally claimed an authoritative position in the art world. Today it is by far the most ubiquitous medium within contemporary art, but in many ways that status has been achieved at the expense of the single image. Since the late 1960s, many of the artists who have turned to photography have diverted attention away from the individual photograph by choosing to emphasise the medium's serial potential or exploring its archival associations. Artists such as Andy Warhol, Ed Ruscha, Bernd and Hilla Becher or Gerhard Richter, whose photographic work has been enthusiastically received within fine art contexts, place little emphasis on the autonomy of the single image.

With the advent of digital media the multiplicity of photography has only been reinforced. We now take and discard more images than ever before. Everything seems quicker, easier, more ephemeral, and the enduring single image is in many ways more elusive. This book is not a rallying cry for a return to modernist values, nor an argument for the authority of 'the decisive moment'. It is simply an exploration of the different ways in which remarkable photographs can stand alone, and of the value of concentrating on their singularity.

Although the book spans the full 170-year history of photography, it begins and ends with two photographs that have a surprising number of elements in common. Both William Henry Fox Talbot's *Latticed Window*, made in 1835, and Jeff Wall's *A view from an apartment*, made in 2004–5, show the view from a domestic window. In each case the subject operates as a metaphor for the way in which photography literally frames a view onto the world. And in each case the image has been laboriously constructed by experimenting with the latest technological possibilities. The result, in both instances, is remarkably unstable.

Talbot's image is literally disappearing. Strictly speaking it is a photographic negative (a sheet of paper brushed with silver nitrate onto which the image of the window was exposed over a period of about an hour) and, in spite of Talbot's efforts to fix it with a salt solution, it has faded dramatically. Many of the details in the picture are barely decipherable today and *Latticed Window* is fast becoming become more important as a photographic legend than an actual object.

Wall's *A view from an apartment* is unstable in a different way. It belongs to a new era within photography in which images do not necessarily document coherent domains in the visible world. Like many contemporary artists, Wall uses computer technologies to montage a number of discrete photographic elements into a semi-fictional scene (in a similar way to that in which a traditional painter composes and paints a picture). He is excited by the way in which digitally generated photographs need no longer assert the ontological consistency of the world around us, but can allude to multiple, less determined, worlds:

> Before photography, the coexistence of separate domains was
> taken for granted. Paintings showed angels or demons interacting
> with humans, for example, as a routine matter ... and that's one
> of the main reasons why they have been so significant in the
> history of the imagination. Photography seemed to be something
> quite different, at the beginning; it seemed to prove that there
> was only one world ... But I think that is only a suggestion made
> by photography, not a conclusion.

The mutability of photographs is central to this anthology. By dint of their reproducibility, photographs have a tendency to become unhinged from their original context and to reappear in unexpected and often incongruous places. And when they do, their meaning is always coloured by the framework through which we see them, be it in an album or an archive, an exhibition, a magazine or a book. In this respect they can be likened to the fictional carbon atom in Primo Levi's book of essays *The Periodic Table* (1975). The atom in question begins its adventures in 1840 when a piece of limestone is hewn from a cliff and sent to the kiln. (Levi chose the date quite arbitrarily, but it so happens that at around the same time two more celebrated chemical reactions took place in the hands of Louis Daguerre in France and Henry Talbot in England, resulting in the invention of photography.) As the limestone is roasted, the carbon atom becomes unstuck from the calcium to which it has been tethered for millennia and begins an

extraordinary journey of appearance, disappearance and transformation. We follow it as it is 'caught by the wind, flung down on the earth, lifted ten kilometers high ... breathed in by a falcon ... dissolved three times in the water of the sea ... borne by the wind along a row of vines ... and nailed there by a ray of the sun'. At an atomic level its properties never change, but as the years pass it appears and behaves differently as it associates with other atoms. We encounter it bound to oxygen as carbon dioxide, combined with hydrogen and phosphorus in the ring of molecules known as glucose, severed to become part of a lactic acid chain, and reoxidised once again.

In a similar way the images whose stories are told in this book have appeared and reappeared in various guises. Some of the earlier essays concentrate on the lives of particularly celebrated photographs, documenting the ownership of rare prints by significant owners or tracing their inclusion in major exhibitions and publications. Others focus on less well-known or newer works to which narratives are only starting to adhere. In some instances it may seem brutal to have isolated particular images from larger bodies of imagery to which they usually belong (Nan Goldin's *The Hug* or Hiroshi Sugimoto's *Aegean Sea, Pilion* are obvious examples). But in the end it is the fate of all photographic images to have multiple careers. Like the carbon atom, they may lie quiet for years, surface in inhospitable environments, be incongruously or favourably paired, misunderstood or imaginatively reinterpreted. The most remarkable ones are always remembered.

Latticed Window
(with the Camera Obscura)
August 1835

When first made, the squares
of glass about 200 in number
could be counted, with help
of a lens.

William Henry Fox Talbot
Latticed Window (with the Camera Obscura), August 1835 1835

By Geoffrey Batchen

The best object to begin with is a window & its bars.
—William Henry Fox Talbot, 4 March 1839

William Henry Fox Talbot, the English inventor of photography, suggests we begin with a window. True to his wishes, let's take as our starting point the picture he himself made of a latticed window in the South Gallery of his own home, Lacock Abbey, in August 1835. He had rebuilt this particular room as a potential art gallery after moving in to the Abbey in 1827. The space featured three bay windows, but he chose to photograph only the central and smallest one, at a point where the room narrows into little more than a wide corridor. The image is lilac in colour, slightly irregular in shape, and about twice the size of an American postage stamp. It has been mounted on a square piece of hand-blackened paper and then fixed to a rectangular sheet of writing paper, on which the following inscription is written: 'Latticed Window (with the Camera Obscura) August 1835 When first made, the squares of glafs [sic] about 200 in number could be counted, with help of a lens.'

This is an important specimen of his work: it offers Talbot's own interpretation of the picture, amounting to an instruction on how we should read it. He was showing photography to the public for the first time, and clearly wanted people to look at it in a particular way. His language still penetrates our perception of this window-picture today, framing our viewing experience, prescribing it, directing it, perhaps even limiting it.

The text was probably written when *Latticed Window* was exhibited by Michael Faraday at the Royal Institution on 25 January 1839. That its wording influenced viewers can be seen from a description of the work, which appeared in the *Literary Gazette* a few days later: 'an oriel window of many feet square is reduced to a picture of two inches, in which every line is preserved with a minuteness inconceivable until seen by the microscope'. A breakdown of the annotation's components is useful. By pointing out

that this is a 'Latticed Window', for example, Talbot reveals the presence of visual details that will only be fully revealed under magnification. The phrase 'with the Camera Obscura' ensures that we distinguish this image from the contact prints that he was also exhibiting at the time; produced using a camera, this one was harder to make and perhaps embodies a greater potential for the new medium. By including the date 'August 1835' Talbot gives this image a history, but also makes a case for its precedence over Frenchman Louis Daguerre's competing claim as the inventor of photography. 'When first made', however, amounts to an admission by Talbot that his process is still far from perfect, since his image has apparently already begun to fade after only four years of exposure to light (it is nowadays too unstable to be exhibited). With 'squares of glafs', Talbot seems anxious that we see ideal geometric forms; he ignores the fact that the panes of glass are actually diamond in shape. 'About 200 in number' is an odd statement, revealing that either the photograph or Talbot's eyesight, or even his magnifying glass, is far from perfect, because there are at least twice that many panes of glass. Finally, 'with help of a lens' shows that he is treating the photograph as a kind of scientific specimen requiring closer examination. He instructs us on how we should see his picture: we must look first with the naked eye and then by means of an optical prosthesis. This is a concession that the naked eye can no longer be guaranteed to provide the viewer with sufficient knowledge of the thing being looked at. It speaks of the insufficiency of sight, even while making us, through the shifts of scale and distortions of image that come with magnification, more self-conscious about the physical act of looking.

Talbot tells us to look closely, but only so far; he never mentions the landscape, the silhouetted row of leafy trees that can be clearly seen through the window. It seems that he doesn't even notice this landscape. But its blurred unruliness is made all the more obvious by the sharply detailed, cultured order of the latticework above. The picture then, offers a contrast between nature and culture, order and disorder, detail and effect, but also shows them as inseparable and interdependent. It is as if Talbot wants us to look *at* the window, but not through it. To his notoriously short-sighted eye the window apparently frames nothing but itself.

Accordingly, the most significant content of the image is to be found in the act of looking intently at it, an act fulfilled only when we are able to count the squares of glass. This is a prolonged, deliberate kind of looking that is more akin to adding numbers or scanning a scientific specimen than appreciating a picture. In fact, if we stick to Talbot's written directions, what we end up seeing most clearly is the act of seeing itself.

Talbot's photograph shows us a window but its transparency to this object is somewhat deceptive. Firstly, the image is in miniature and thus provides a very different kind of vision of things than does a one-to-one sized contact print. And what are we actually looking at through our magnifying lens? It's a picture of a window, right? Actually, it's not: it's a picture of a mirror image of a window. We don't see that inversion at first, because the image is so symmetrical. Only when we peer closely, and with some understanding of how this image was made, do we realise that we're observing a window and a mirror at the same time, as if we're simultaneously looking at it and away from it (as if our backs are to the window and we're seeing it reflected in a mirror opposite). This photographic mirroring effect would soon become a common experience. But those looking at their first photograph ever are faced with a system of representation that appears to be an impossibility, something both transparent and opaque, both a reflection and a projection. No wonder Talbot wants us to look at but not through this image, for it turns out to be an articulation of photography's representational function, as complex as any offered by subsequent philosophers, in his time or our own.

This photograph is a picture of a window, or, as Talbot insists, of just that window's frame. Maybe we should delete that word 'just'. For what could be more full of potential significance for a photograph made with a camera than a picture of a window frame? It is a photograph of a viewing device that separates the viewer from what is being viewed, a spacing of subject and object according to the rules of artificial perspective. In his 1435 treatise, *Della pittura*, the Italian architect and writer Leon Battista Alberti speaks of perspective in terms of mathematical principles and geometric diagrams and then talks of representing all this in the form of a drawing that he imagines as an 'open window through which I see what I want to paint'. Seen in these terms, Talbot's picture is a photograph of the viewing device at the heart, literally and metaphorically, of the invention of monocular perspective, that system of representation so faithfully reproduced by the camera in which this photograph has been made.

Another interesting thing about Talbot's 1835 picture of the inside of his oriel window is that it is one of many. He repeated this same basic composition – with its flat pattern of diamond shapes framed by the more solid outlines of the window structure – in at least nine other images, and maybe many more, some also made in 1835 and others perhaps dating from four years later. Most of these photographs also show the window directly, head on, and without any compositional embellishment. By this means, Talbot is able to produce a virtually abstract image that emulates the equally

flat and already familiar two-dimensional look of his contact prints of botanical specimens. It is as if he wants to tell us that this window has imprinted itself directly onto his paper, without the mediation of composition or artistic precedent.

The South Gallery at Lacock Abbey incorporated some of the remains of the original convent that gave Talbot's home its name. Could his picture of the middle window in that Gallery, isolated and abstracted into a symbolic source of light by his framing, have had some theological significance? His mother certainly made the connection. In a letter dated 23 April 1839, Lady Elisabeth explicitly praises one of Talbot's photographs of the oriel window for looking 'so conventical & of a Rembrandt tint'. His decision to add windows in this 'conventical' style was in keeping with the revived taste for Gothic architecture that came to be associated with English Romanticism. With the decision, made in February 1836, to rebuild the Houses of Parliament in the Gothic Revival style, this type of architecture soon came to be identified with English nationalism itself. In the context of 1839 and the prior announcement by a Frenchman of the invention of photography, the overt Englishness of Talbot's window picture was no doubt apparent to all who saw it.

His series of window pictures was made by pointing his camera directly into the light. And it is striking how many of Talbot's other early images are similarly suffused, almost overwhelmed, with light. Barely visible to our eye, his photographic subjects sometimes appear surrounded by a penumbric halo, as if we are looking straight into the sun, blinded by its radiance. In this aspect, Talbot's photographs might be equated with J.M.W. Turner's extraordinary 1843 painting, *Light and Colour (Goethe's Theory): The Morning after the Deluge – Moses Writing the Book of Genesis*. Both propose that seeing, once thought to be a reliable and unmediated reflection of an outside world, is now situated in and identified with the body of the individual human observer. Goethe, for example, had in 1810 proposed a series of simple experiments in which one stared into bright light or at coloured objects and then closed one's eyes. His point was that the observer continued to see a shimmer of colours and shapes, a retinal afterimage produced, he argued, by the eye itself. Turner's painting represents the look of this new self-reflective eye via an image that is at once elemental (light and colour), theoretical (Goethe's theory) and theological (Moses writing the book of Genesis).

Talbot's imagined observer, the one bent over his window picture with a magnifying lens, is faced with a similar sensation. Encouraged by the photographer to look directly into the source of light, this observer sees

there a kind of image never before seen, a miraculous proof of the wonders of science inscribed by light itself in the form of mathematically verifiable squares. His conception of photography coincides with the accelerating disintegration of natural philosophy as a mode of knowing the world, and is therefore closely related to the poetry and painting produced during this period. His contemporaries, such as Turner, Samuel Taylor Coleridge and John Constable, are intensely interested in the representation of seeing (and in the idea that *what* we see is conditioned by *how* we see, even by *who* it is that sees). No stranger to Romantic poetry, Talbot was also very familiar with the new attention being given to the constitutive physiology of the eye. In 1818 he wrote to his mother to tell her that he had been 'reading books on the structure of the eye' and about his own experiment in this area. He had gently pressed his eye with his finger in an attempt to improve his congenital shortsightedness; a more distinct vision was the result. Through such simple experiments as these, the human body, in all its contingency and physical specificity, was shown to generate its own images.

A few years later, in 1826, Talbot devised a 'Revolving Photometer or Measurer of the Intensity of Light and Colour'. This machine employed a colour wheel on which could be mounted spiral-shaped sectors, which when spun would exhibit a changing mixture of one colour with another along the radius of the wheel. More importantly, it embodied in apparatus-form an ongoing exploration of the connection between optics, colour theory and physiological effects. This was also true of Talbot's photographic work. In fact, Talbot's *Notebook M*, begun in December 1834 and containing the first record we have of his use of the word 'photogenic', is also full of references to his experiments with a Phentascope, an instrument specifically designed to explore the human eye's persistence of vision. Almost thirty years later, in 1860, George Henry Lewes, in his *The Physiology of Common Life*, suggested that if 'we fix our eyes on the panes of a window through which the sunlight is streaming, the image of the panes will continue some seconds after the closure of the eyes'. Talbot's serial rendition of his own window demonstrates precisely this afterimage effect, projecting the photographs that result as retinal impressions, retained even after the eye of his camera has been closed. In other words, Talbot's sensitised camera obscura acts in place of his own eye, as a detachable prosthesis of his own body; he himself referred to the 'eye of the camera' in *The Pencil of Nature* (1844–6).

Perhaps we can now see that Talbot's camera also looks at this window from the perspective of Talbot himself, as if the photographer is leaning up against the wall opposite (literally standing in the place of the developing photograph). His picture reproduces Talbot's own looking, but at the same

time it provides the look of this new medium, photography. For Talbot has set up his photographic apparatus at exactly the point in the South Gallery where the sensitive paper once sat in his own modified camera obscura. Placed at the back of the room looking towards the window, his photographic camera looks out at the inside of the metaphorical lens of the camera of his own house. What we are witnessing here, then, is what one camera sees when it is placed inside another. He is presenting us with a photograph of photography at work on this very photograph.

Perhaps I have gone too far. Perhaps I have made too much of a photograph that is after all a straightforward example of Talbot's new process. And maybe that's all it is: a simple, repeatable and convenient test of the efficacy of photogenic drawing. Using this sheltered latticed window as his subject, Talbot could periodically test his equipment and its focus, as well as his chemical solutions and their relative exposure times. There is in fact some evidence to support this instrumental view of his window pictures. On 4 March 1839 he wrote a letter to his cousin Charlotte Traherne about her own 'experimentalizing' and in it he basically describes both the impetus and the process that led to his own photographs of windows.

If you intend making use of the camera, you must first acquire the art of making the *most* sensitive paper by repeated trials; and then I advise *not* using at first a regular instrument bought at an opticians [sic], but a large lens of short focus, such as a very strong reading glass or magnifier, & fixing it in a board & the paper upon another, exactly in the focus & excluding all extraneous light. The best object to begin with is a window and its bars, placing the instrument in the interior of the room. If you don't succeed tell me & I will see if I can help you further. The lens must be as large as possible *compared with its focal length*; if it makes a good *burning glass*, it will answer.

So, for Talbot, a picture of the inside of a window is an exemplary photograph, the first photograph one should attempt, the origin point of one's photography; the origin therefore of *all* photography. He asks us in his note to look right at his 1835 window picture because to do so is to look directly at photography itself. In fact, he asks us to look at photography's origin point through the same burning glass that the camera once looked through, as though to turn each of us into a camera, collapsing any distinction between us and the photograph we are seeing. At the same time, his letter above provides a technical exposition of the window pictures, treat-

ing them merely (or at least primarily) as exercises in focal length and paper sensitivity.

This raises the question of intention. Is the key to the meaning of this picture to be found in Talbot's stated intentions, at least as they can be divined from this letter or his brief note on his photograph, or should we work from the assumption that the meaning of an image always exceeds and often escapes the conscious understanding and intentions of its maker? To what degree is that meaning to be found in some originary moment of an object's manufacture, and to what extent in the image itself – its physical form, its visual rhetorics, its overt and covert references, its cultural context, its potential and actual effects?

This essay makes a case for the second of these options, acknowledging Talbot's own voice while also treating his photographs as objects whose contemporary implications go well beyond his own capacity to know or say. The end result may be speculative, but so is all history writing (true to Talbot, I invite you to look right at, as well as through my essay). In this context, we would perhaps do well to remember Talbot's own wise words: 'It frequently happens, moreover – and this is one of the charms of photography – that the operator himself discovers on examination, perhaps long after-wards, that he has depicted many things he had no notion of at the time.'

This essay is an abridged and edited version of 'A Philosophical Window', *History of Photography*, vol.26, no.2, Summer 2002, pp.100–12.

)

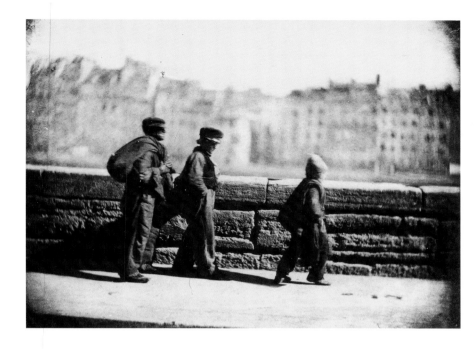

Charles Nègre
Chimney Sweeps Walking 1852

By Mary Warner Marien

Soon after photography was revealed to the world in 1839, its strength – the ability accurately to depict the observable world – was also judged its greatest weakness. Photographs seemed mired in the mundane task of performing literal transcriptions, and were therefore considered to be as far from expressing the vision of the artist as earthworms are from angels. The general consensus about what constituted a good painting seriously threatened photography's potential to be seen as an art. If the new medium were to ascend to that exalted state, it seemed that it would need to reject its unique ability to render exact and naturalistic depictions.

Some early painter-photographers, including Charles Nègre, were open to testing the medium, to see how far, if at all, it could be adapted to the tenets of academic painting, whose champions recommended that an artist generalise shapes while creating an overall, abstract, harmonised pattern of light and dark tones on the picture plane. In doing this they found it essential to integrate experimentation with chemistry and optics, even as they explored the medium's loftier conceptual limits.

Much is made of Nègre's early enthusiasm for photography. However, during his most productive era in the mid-1850s, he also produced a significant number of canvases, and never stopped painting, even when, later in his career, photography occupied most of his time. Some of his photographs acted as preliminary sketches for his paintings, but Nègre also practised the two media each for their own sake. It was as if he did not feel pressed to decide between them. For most of photography's history, painting and photography have been understood to influence each other detrimentally. But in Nègre's era, as in ours, artists were not expected to choose between the two, albeit it for very different reasons.

Less than a decade after his animated response to a demonstration of how to make a daguerreotype, which took place in the studio of his painting master, Paul Delaroche, Nègre seems to have felt sufficiently confident to investigate what could be achieved in photography by relating the medium

to what was expected of painting. For him, that did not mean copying the look of painting, but infusing the photograph with the presence of a discerning mind and hand. Thereafter, working intensely in both media became the pattern of his professional life. Indeed, fruitful yet unresolved dualities characterised his best photographs, like *Chimney Sweeps Walking*, which can be interpreted within a cluster of contrasting ideas about what an art photograph might be.

Nègre's studio education under Delaroche, and, briefly, with Ingres, was conservative and traditional, designed to prepare him for a conventional career as a painter. It would have introduced him to stock figures in the history of genre painting, such as the drunkard, the scold, the tart, the cherry-cheeked child. Also fashionable during Nègre's years in Paris were the genre figures of the Spanish painter Murillo, which often included threadbare beggar children. Nevertheless, Nègre did not faithfully translate these characters into his photographs. Instead, he pictured Paris's lower-class urban workers, such as an organ-grinder, a rag-picker, a watercress seller and a vendor of licorice water – people who made their livings through contact with customers on the street or in public markets. They haunted the markets and walked the streets, hawking their goods and trades.

Because their work helped prevent fires, chimney sweeps were probably the most valued of Nègre's urban subjects. Like London, Paris in the 1850s received waves of people transplanted from small towns and rural areas. As the population grew, so did the danger of fire, caused by the little charcoal burners that the poor used for warmth, and by chimneys loaded with flammable soot. Thus chimney sweeps were a familiar sight on the streets, but, lacking the sentimentality or ribald humour associated with figures typical of rural paintings, they were not a common subject for image-makers. Nègre found the three sweeps depicted in *Chimney Sweeps Walking* across the street from his apartment on the Quai de Bourbon, near the Seine. The parapets and areas near the river would soon be made famous by Honoré Daumier in his paintings of laundresses, such as *Washerwoman on the Quai d'Anjou* of about 1860.

Given the technical limitations of photography in the 1850s, Nègre had to compose his images like an art director arranging props and giving cues to models. In most of his photographs of street life and people, the figures are immobile. For instance, in his two images of a rag-picker, the young man either slumps against a wall or leans on his large collection basket. Other subjects pose with a determined tautness, as they wait out the long seconds required for the camera to register their image.

But for *Chimney Sweeps Walking* – named, as Nègre's works often are, according to what it depicted – he chose to trick the camera image into suggesting movements that were too quick for it to register. Lining up the chimney sweeps according to height, he asked the smallest one to look straight ahead and to step forward onto the toe of his right shoe. His left foot is turned sideways to balance the stance. Behind this boy, the next sweep also seems to feign forward motion. His feet, and those of the last sweep, are nearly obliterated by the shadow that stretches backwards from the first boy to his two companions. In effect, Nègre did not so much show movement as encourage the viewer's willingness to accept signs of motion as the real thing.

Although it has become the most famous of Nègre's images, *Chimney Sweeps Walking* was not his only picture of these particular sweeps. It was one of a series of four views made on the same spot, presumably on the same day. One image shows the child and the second tallest figure sitting against the wall and facing the camera. Their heads do not reach the top of the parapet's large, flat stones behind them. In addition, the light has washed out their facial features, further diminishing their presence. The figure with the largest sack has his back turned to the street, and he seems to be looking over the wall and down to the wide pavement along the river. The image offers no hint of a relationship among the figures. They may or may not know each other.

Nègre took two more photographs of the sweeps and printed each of them as small, circular images. In one, the child is the only figure. He stands flat-footed, facing right, with his left hand lightly braced against the wall. In the other, the tallest man is flanked on either side by the two shorter figures. Each of the chimney sweeps extends a right leg and the central figure leans forward. Their feet are flat on the ground in a poor pretence of walking that makes them look more as if they are playing a game of statues.

Chimney Sweeps Walking itself exists in two prints, the dark-toned one illustrated here, which was part of the famous French collection held by André Jammes, and a lighter-toned one, now in the National Gallery of Canada in Ottawa. The Canadian photograph is slightly smaller than the Jammes version and it appears that it, or the negative from which it is printed, was cut down a little. Oddly, the Canadian version, which may have been printed later than the other four pictures of the sweeps, is the only version signed 'C. Nègre'. Given the angle of the sunlight, all four images appear to have been made in the morning, but even that is debatable.

We may look at this picture today and let it lead us into a reverie about times past or a contemplation of the suffering of the poor. Yet we cannot

assume that a viewer in the 1850s would react as we might. After all, this was the era of child labour in factories, which was mostly not photographed, probably because actual impoverished children lacked the charisma they often had in paintings. In the early 1850s there were very few social activists who, like the English writer Henry Mayhew, considered photography a tool to be used in the reform of society. In fact, the term 'documentary photography' had yet to be coined to describe what would eventually become a familiar category of visual evidence in the twentieth century. Also, photographs could only be reproduced in publications by being hand-transferred to engraving plates, unless actual photographs were pasted in – a time-consuming and expensive operation. It is interesting to note that Nègre believed that the future of photography was in engraving, and he patented a successful photogravure method in 1856.

One of Nègre's contemporaries thought he could see the chimney sweeps' 'shivering limbs beneath their rags', but he quickly turned away from their hardship to remark that the image was picturesque in the manner of Murillo. In sum, although this photograph may seem today to be a visual verification of adversity, the attitudes, social systems and distribution networks in which it could function and achieve that meaning did not exist in Nègre's time. That does not mean that Nègre was unaware of the precarious lives of street vendors, but it implies that he might have had other motives for making the image.

The amount of handwork Nègre performed on the photographic negative indicates that he was testing the limits of the medium, asking at what point camera work could become art work, or whether handwork could ever transform a mere photograph into a drawing. In addition to posing the sweeps, he extensively altered the negative to create visual effects that the camera alone could not. He seems to have used a pencil to blur the sharpness of the buildings in the background, muting their details especially in the central area of the work, so as not to distract from the foreground figures. As a result, the buildings look as if they have been painted on a theatrical backdrop. This dramatic feel is furthered by Nègre's combination of natural light with handmade effects, as on the top of the stone wall where he has enhanced the highlights with a pencil tool to darken the negative. The result is a stark white bar across the photograph's mid-section, which accentuates the different heights of the figures, and pushes the figures into the foreground, as if they were part of a sculptural frieze. To achieve a similar result, Nègre may also have delicately highlighted on the negative the stones behind the figures.

Given all this tinkering, why did Nègre refrain from removing the smudges in the four corners of the print? Some critics suggest that he used

a technique known as edge burning, to create the sense of a frame around images grabbed from the flow of transient figures on the street. But the effect might also evince a well-known flaw in photography. In the mid-nineteenth century, camera lenses rendered more visual information in the centre of the image than at the corners. The lens, being round, directed a circular spray of data on the rectangular surface of the negative, leaving the far corners blank or blotchy. When printed, these corners look dark and spotted. Some photographers disguised this effect by composing their images so that dark forms, like vegetation, fell in the lower corners, and trees overhung the upper corners. Others trimmed away the effect, or created mats that covered it.

Since he seems to have had his pencil at the ready, Nègre could have expunged or softened the marks, but chose not to do so. He retained the telling signs of photographic production. While there is no way of knowing what he had in mind, it is conceivable that he was deliberately drawing attention to the image as a photograph, as opposed to a drawing or painting. This would resonate with another suggestion within this work.

As noted above, the white bar that pushes the figures forward accentuates their differing heights. Taken together with the linear elements of the stone wall, the effect is like that of graph lines, emphasising the dissimilarity of the figures in terms of body type, and, by inference, age. The first figure is obviously a child. He wears a child's cap and he carries a lighter sack of equipment. He is the most animated of the three, and strides ahead of them. The middle figure is taller than the child, dressed like a young man, and he wears the kind of cap that an adolescent or young man might wear. The sack he carries is fuller than that of the child. His gait is midway between the energetic forward thrust of the child and the near-still stance of the figure on the far left, who also wears a cap associated with adulthood, and who is marginally taller than the middle figure. This third man's sack seems to be the largest, and, perhaps to emphasise that feature, Nègre has him sling it onto his back. He leans forward, but his feet are firmly planted on the ground. As a design, Nègre's arrangement animates the scene, and thereby moves away from his static images of urban workers. In addition, these sweeps seem to pay no attention to the camera, whereas genre figures usually look straight into it.

Nègre's treatment of the figures might be evoking the enduring ages-of-man theme that had pervaded Western art and literature for centuries. Sometimes the ages of man, and of woman, were extended to five or seven periods, but three – childhood, youth, and old age – were the basic stages. The theme was popular in Late Renaissance art, where it were rendered by

Titian and Giorgione, and made famous in engraved reproductions. Ages-of-man pictures generally use visual devices to set apart and also relate the successive time periods. Nègre's possible evocation of the ages-of-man iconography is supported by his obscuring of the figures' faces. In his photographs of other street types, such as the organ grinder and the licorice-water vendor, distinctive facial features are evident. By contrast, the natural and hand-made light that illuminates the ground and the top stones of the wall does not reveal the physiognomy of the sweeps. A close look shows that the face of the child is only an implied profile, adroitly suggested in the negative space of the blurry background. The middle figure looks down, putting his face in the shadow of his cap peak. Although he looks towards the camera and the viewer, his face is a silhouette. The eyes of the third figure, presumably the oldest, are also shadowed by his cap brim. A jot of light around the mouth gives it an uncanny highlight. In effect, Nègre concealed the faces of all three sweeps, allowing them to suggest something beyond themselves. If – and it must remain a conjecture – Nègre adopted the ages-of-man theme and cast it with humble chimney sweeps, he was unique in giving the new medium of photography over to a new subject, the emerging, industrialised city and the notion of the worker as a modern heroic figure.

In his time, it was nearly unthinkable to use lowly street folk for such a noble theme as the ages of man. This may be why Nègre leaves the visual suggestion deliberately suspended between document and symbol. The very lack of resolution is a powerful visual metaphor for being in-between, just as the chimney sweeps move from somewhere we cannot see to somewhere that is beyond our vision. In his 1846 essay on the heroism of modern life, Charles Baudelaire declared that a great tradition, presumably the classical heroic, had been lost, and that a new one, the modern heroic, had not yet been established. He urged artists to recognise their subjects in the pageant of life on the street, whose protagonists, like the three chimney sweeps, rush by largely unnoticed. But are Nègre's chimney sweeps heroic? We may interpret the way in which the boy strides ahead of the older figures into the sunlight as an indication that he is freeing himself from their world. But we can also reach a more grim conclusion: that this is one figure in three stages of life: the youth whose joyful skipping will become the stolid gait of the earth-bound old man; once a chimney sweep, always a chimney sweep. Certainly this interpretation seems closer to mid-nineteenth-century reality.

In his exuberant comments on Nègre's work, Francis Wey, the indefatigable mid-nineteenth-century critic and cheerleader for paper photography,

characterised what he thought Nègre was trying to do with his art. Writing about one of his photographs of the young rag-picker, he told his readers that the image was no longer a photograph, presumably meaning that it had moved away from the verbatim depiction inherent in the daguerreotype. He would have seen the handwork in that picture and understood it as a way to enhance picture-making. Certainly, he seems to have understood that Nègre's image was thoughtfully composed by the photographer through an act of will that separated it from mechanical rendition and moved it closer to the principles of art.

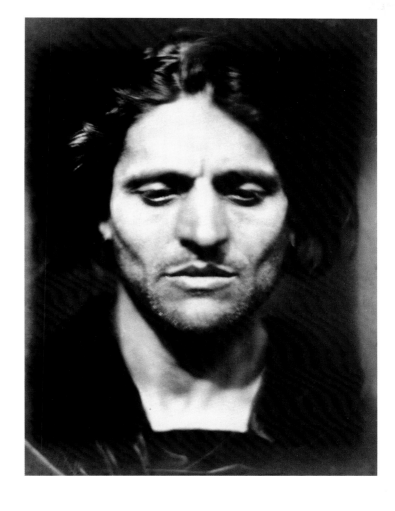

Julia Margaret Cameron
Iago, Study from an Italian 1867

By Roger Hargreaves

Tis true; there's magic in the web of it
—William Shakespeare, *Othello*, 1602–4, Act IV, scene ii, line 46

'We've chosen Iago as the key image for the exhibition', someone from the communications team explained. 'We want to integrate publishing, press and marketing. It'll appear on the banners, the posters, the press advertising and the catalogue jacket. It's the kind of image that says "nineteenth century" but could be equally at home printed on T-shirts worn up and down Old Compton Street. It's got that contemporary, cross-over appeal.' A group of staff from across a range of functionary departments of the National Portrait Gallery had come together in preparation for the forthcoming exhibition, *Julia Margaret Cameron: 19th Century Photographer of Genius*. The subtitle had been added as a pun on Cameron's genius as a photographer and her practice of head-hunting with her camera the male cultural icons of mid-nineteenth-century Britain. Cameron's portrait, *Iago, Study from an Italian* was re-photographed, scanned and mutated into a myriad of forms in advance of the exhibition's opening in February 2003 and its subsequent tour to the National Museum of Photography, Film and Television, Bradford, and the J. Paul Getty Museum, Los Angeles. As promised, it appeared on T-shirts, posters, canvas bags and button badges. The badges were later withdrawn because the image had inadvertently been printed the wrong way round. More tellingly and rather elegantly, Iago was converted into data and projected onto the screen wall at the entrance to the exhibition where he flickered like a movie star, luring visitors into buying tickets to view the real thing.

What had not been discussed at the earlier planning meeting was that this particular photograph had also been central to the formation of the photography collections of two of the three exhibiting institutions: the National Portrait Gallery and the National Museum of Photography, Film and Television. By extension, it had also helped shape the maturing cultural

status of photography as a specialist subject for museological, academic and commercial interest. This fulfilled Cameron's promise, made in 1864 in a letter to Sir John Herschel, that: 'My aspirations are to ennoble Photography and to secure for it the character and uses of High Art by combining the real & Ideal & sacrificing nothing of Truth by all possible devotion to Poetry & beauty.'

The photograph was made in 1867. Colin Ford, who curated the 2003 exhibition of Cameron's work, has suggested that it was probably taken at the studio of the painter G.F. Watts in Little Holland House, London. Based on the similarities between the portrait and the appearance of the model in a number of Watts's paintings, Ford has also ventured the opinion that the sitter was Angelo Colarossi, a professional artist's model who had moved to London in the mid-nineteenth century and was one of a group of émigré Italian models whose classical physique and chiselled Mediterranean looks ensured regular employment. As well as sitting for Watts, Colarossi posed for a stellar cast of nineteenth-century artists, including Lord Leighton, John Singer Sargent, John Everett Millais and Edward Burne-Jones. Colarossi's son, also named Angelo, achieved a certain type of urban immortality as the model for Alfred Gilbert's landmark statue of Eros in Piccadilly Circus. It is not clear whether Watts suggested the model to Cameron or whether, on one of her frequent visits to his studio, she had spotted Colarossi and at once discerned the possibilities of translating his remarkable looks into a photograph. It was certainly within her powers of persuasion to inveigle the Italian into sitting for her for free. Also un-certain is whether the idea of casting him as Iago had occurred first or whether, as was so often the case with Cameron, the title of the photograph was applied later to suit the image.

There may, however, be a clue in the wording Cameron chose for the brief descriptions she provided on the official entry forms for the photographs she copyrighted between 1864 and 1875 at the Copyright Office at Stationers Hall off Ludgate Hill in London. In the theatrical portraits, a picture of Mary Pinock, for example, is described as 'Mary Pinock as "Ophelia", profile, bust', just as Selina Wilson is cast as 'Aurora' and a 'male and female' appear 'as Romeo and Juliet'. Her portrait of Iago, by contrast, is described as 'Male, bust, full face entitled "Iago"', as if the title were an afterthought. It was included in a group of nine photographs registered on 4 July 1876 during what had quite clearly been a high summer of theatrical photography.

Amateur dramatics and what Colin Ford has described as 'the Victorian predilection for tableaux vivants' – living-picture games of dressing up and

frozen performance – emerged as a central practice in Cameron's photographic oeuvre. Her love of theatre and literature was allied to the irresistible attraction of assuming the directorial role, whether in homespun plays or behind the camera in her studio, both of which afforded her the licence to bend her cast of performers to her controlling will. Edith Nicholl, the daughter of Alfred Tennyson's close friend George Granville Bradley, said as much when she recorded her own experiences of performing in a Cameron-directed parlour play: 'She was as severely exacting in this direction as she was in her photography ... During some of the rehearsals Mrs Cameron became very much displeased with the backwardness of her troupe in ... some of the love scenes ... "Oh heavens, Henry!" she cried. "Do you call that making love? Here let me show you how to do it!"'

Cameron's absolute conviction in knowing what she wanted is evident in her portrait of Colarossi, and what gives the photograph its contemporary feel, making its translation to filmic projection in the National Portrait Gallery so effortless, is the understated performance she elicited from her model. Part of this was achieved through coming in so close to the sitter with her camera, creating an intimate and charged space and attending to the nuance of small facial gestures. In 1866 she changed cameras, buying a model that utilised larger fifteen by twelve inch plates, fitted with a Dallmeyer Rapid Rectilinear lens. The shift in scale and optics gave her the technical opportunity to explore through photographic portraiture, for the first time, the extreme close up – something that has since become the leitmotif of modern cinema.

The process of plate-camera photography requires the photographer initially to focus and frame the image, viewing it projected upside down and back to front on the ground-glass viewing screen at the back of the camera. The photographer is usually shrouded under a dark cloth, fumbling mysteriously with the focusing levers and extension bellows. The disorientating inversed and reversed projection divorces the photographer from the emotional content of the photograph, allowing him or her to concentrate instead on its compositional and graphic qualities. Once set, the plate is loaded into the camera and exposed. At the moment of exposure the photographer can no longer see through the camera, but comes round the front, dramatically re-emerging from beneath the dark cloth to exploit a heightened moment of studied physiological intensity.

What must Colarossi have made of this passionate English woman who had stepped inside the zone of professional distance he was used to maintaining with male painters and sculptors? Her camera would have been set just inches from his face, her extortions delivered within breathing

distance, so that he would have caught the odour of chemicals that emanated from her. Cameron's great-niece Laura Guerney later described her own childhood experiences of sitting for 'Aunt Julia', whom she recalled 'appeared as a terrifying elderly woman, short and squat ... dressed in dark clothes, stained with chemicals, with a plump eager face and piercing eyes, and a voice husky and a little harsh, yet in some way compelling and even charming'.

To an Italian – even one resident in London and familiar with the foibles of the bohemian artistic community – her behaviour must have seemed odd, at best. The curator of the Gilman Paper Collection, Pierre Apraxine, speculated in an interview with Beth Gates Warren on the reason why a handful of British women emerged as some of the most significant photographers of the 1860s while in France photography remained an almost exclusively male preserve. 'In 19th century France,' he noted, 'the lives of men and women were more integrated than in Great Britain. In England, men led their lives, and women theirs, so English women could appear dishevelled in public, like Julia Margaret Cameron, with messy chemical stains on their hands.' More crucially he observed that:

> there has always been a respect for idiosyncratic behaviour
> in Britain that has not existed in France. More to the point
> there existed in mid 19th century France an essentially
> bourgeois society in which conformism was very important,
> and the eccentric was somewhat of an outcast. And amateur
> photographers, and most definitely women photographers,
> would have been considered eccentric. England on the
> other hand, had an aristocratic society where originality was
> cultivated and the eccentric did not conform because it
> was her birthright not to.

Whether culturally confused or morally affronted, Colarossi's true feelings are concealed behind a mask of downward-glancing professional concentration. It is perhaps this recognition of the studied and professional performer that inspired Cameron to dub her portrait 'Iago'. The reaction she provoked in him, either as a result of her knowing strategy of persuasion or of her overbearing manner, perfectly embodies that most slippery and duplicitous of all Shakespeare's dramatic creations. On Iago's first appearance in the opening scene of the first act of *Othello* he flaunts his virtuosity for deception with the disparaging claim that:

Though I do hate him as I do hell-pains,
Yet, for necessity of present life,
I must show out a flag and sign of love,
Which is indeed but sign. (Act 1, scene i, line 155)

But for all his manipulative skills, Iago is never the true Machiavellian since his manoeuvrings do not bring him any political or material advantages; they lead ultimately to the destruction of those around him and the public shame of his own exposure. By labelling her portrait Iago, Cameron identifies the complexities and ambiguities of her creation, something that she alone seemed capable of exploring through photography and her chosen use of the extreme close up. By comparison, many of her other theatrical set pieces have the look and feel of stage acting, with the performers making the enlarged and exaggerated stage gestures that could be carried to the back of the stalls. Her Iago is much more cinematic, showing an appreciation of how almost imperceptible facial gestures could become the subject of intense scrutiny once the enlarged head was allowed to fill and dominate the frame.

Much has been said about Cameron's selective use of focus. Her submission of five prints to the 10th Annual Photographic Society of London exhibition of 1864 was greeted with the disparaging recommendation that 'She should not let herself be misled by the indiscriminate praise bestowed upon her by the non photographic press, and should do much better when she has learnt the proper use of her apparatus.' Shaping this dismissive criticism was the misinterpretation of her creative use of focus as technical incompetence. In reality she had been inspired by David Wilkie Wynfield, of whom she wrote in a private letter: 'To my feelings about his beautiful photography I owed all my attempts and indeed consequently all my success.' Wynfield's method of deliberately softening the focus to create a more painterly effect in the photograph set his work apart from commercial studio portraitists keen to use the sharp-edged definition of the wet-collodion process, first announced in 1851, to produce forensically accurate depictions. Through her selective use of focus as a narrative device, Cameron elevates what was an artful technique into something more assertively artistic. In the Colarossi portrait she rejects the convention of making the point of focus the eyes, settling instead on the lips. That the moist-eyed model's introspective gaze is also directed towards his tightly pursed lips draws the viewer inexorably to the mouth. Iago's fate, it should be remembered, was the penury of guilt and shame, and his final words are a vow of silence:

Demand me nothing. What you know you know.
From this time forth I never will speak word.
(Act v, scene ii, line 305)

Perhaps, then, it was this final act of the drama that Cameron had in mind when titling the picture, casting her Iago not at the height of his subterfuge, but at the moment of retribution when the layers of deceit were stripped away to expose the venal core. As such, the gaze becomes self-admonishing, part wonderment, part horror at his own powers of persuasion, delivered from a mouth that he has now chosen to seal and a voice he has elected to silence.

We know that Cameron prized the photograph. It was one of the 508 images she had taken the trouble to copyright. Of even greater significance was its placement within the most important of all of Cameron's presentational albums. In 1864 she had printed and sequenced a group of photographs that she gave as a gift to her friend and mentor, the astronomer and pioneer of early photography Sir John Herschel. Three years later, at around the time of the Iago portrait, she took back the album to expand and update it, adding examples of her most recent work. On the front page she pasted her freshest portrait of Herschel, registered for copyright in April 1867. Herschel appears draped in black velvet, set against a dark background, with intense, luminescent eyes staring out from beneath a wild dandelion of hair, which Cameron perhaps leaned forward to tease back over his black cap. It is both a phrenological study of feral intellect and an allusion to the professional status of an astronomer whose work illuminated our understanding of the night sky. Herschel recognised in this portrait the striking originality of Cameron's work, describing it in a letter to her as 'the climax of photographic art which beats hollow anything I beheld in photography before'.

Something must have happened to the collodion glass-plate negative of Iago. As far as we are aware, the print in the Herschel album is the only extant example of the work, marking it out as that rarest thing, a unique photograph. An explanation may be found in a letter of 1869 that Cameron sent to Henry Cole of the South Kensington Museum, explaining the gift of four newly minted photographs. Here she wrote of 'the very latest of all, my last portrait of Alfred Tennyson', which she described in less than modest terms as 'a national Treasure of immense value', before adding:

altho' I can ensure thro' my own care the durability of my print, I can alas do nothing to make durable the far more precious original

negative. The chemicals supplied to me for this are beyond my power & prove fatally perishable. 45 of my most precious negatives this year have perished thro the fault of collodion or glass supplied: both or either destroy the film that holds the picture.

Her response to the dilemma was 'to print as actively as I can whilst my precious negative is still good'. But while this might explain why there are so few surviving prints of certain photographs, it does not reveal why there is only one of her Iago. Perhaps the glass plate slipped through her fingers, smashing on the darkroom floor, or if printed in London at the studio of Watts, was broken in transit back to the Isle of Wight.

The recent catalogue raisonné, published by the Getty Museum, *Julia Margaret Cameron: The Complete Photographs* (2003), provides an impressive inventory of exhibitions of Cameron's work, spanning each and every decade from the 1860s to the present day. What is so remarkable is the evidence that Cameron's photography was never out of the public domain for long. For those seriously interested it was possible, at many points and in many places, for her work to be seen afresh, and her influence has been felt across generations. However, while the sole surviving print of Iago was preserved within Herschel's album, it remained a hidden and private treasure.

In 1974 the descendents of Sir John Herschel decided to sell the album at Sotheby's in London. Auctions dedicated solely to photography first began to appear in 1971, although this was a time when the art market still looked askance at a medium that to their eyes seemed ubiquitous, and to have no agreed canon, little scholarly history and precious few institutional collections. However, a new breed of collector was emerging quietly from out of the shadows, attracted by the promise of an uncrowded, richly stocked and reasonably priced marketplace. Prominent amongst them was the privately wealthy American collector Sam Wagstaff, who was driven by a visceral excitement for photography. For him, assembling a collection became a vicarious form of self expression. Working on the dictum 'photography is silent talk', and that 'you've got to crash through the sight barrier and tell the mind to shut up', Wagstaff honed his eye for the medium through buying, constantly making new discoveries along the way. Sotheby's photography specialist, Philippe Garner, recalls that 'he was testing his tastes in what was uncharted territory. There was a sub-versive side to Sam, putting a V sign to the establishment as if to say, "you guys in your ivory towers, let me show what can be done when you're out on a limb".'

When the Herschel album appeared at auction, Garner was the auctioneer. There exists a competent and apparently anodyne black-and-

white press photograph of the event: two dust-coated attendants, one holding the proffered lot, stand directly beneath the podium at which Garner leans forward into his microphone, the polished mahogany hammer clenched ready in his hand. Garner knew that Wagstaff was not only interested in the Herschel album but had fallen senselessly in love with the Iago print and the image of Colarossi. Wagstaff's resources were not limitless and he had earned a reputation for astute acquisitiveness coupled with an endearing cynicism towards the over-hyped artefact. However, Garner had an instinctive knack of knowing how to bait his quarry. One of the two attendants in the photograph of the sale appears like an adolescent version of Colarossi, clearly hand-picked and coached, all thick black wavy hair, dark, downcast eyes and pursed lips, holding open the Herschel album at the plate of the Iago print. The second, much older, attendant has his eyes cast up at Garner in a look of incredulous disbelief, as if winded by the audacity of the tactic. Wagstaff outbid everyone in the room, setting a new world record price for photography at £52,000. The press picture offers a rare moment of cunning auction-house spin and a light touch of Ealing comedy to counterpoint the Shakespearian tragedy of Iago.

The fulfilment of Wagstaff's desire proved short-lived. Colin Ford, then Keeper of Photographs at the National Portrait Gallery, sought and won the revocation of an export licence for the Herschel album from the Reviewing Committee on the Export of Works of Art. This proved to be the first time the Committee had stepped in on behalf of a photographic work. Ford then set about raising the money required to match Wagstaff's bid through public subscription. 'Sam was tremendously generous about it', he recalls. 'He was desperate to have the Iago photograph, but accepted that it should properly belong in a national museum.'

A book on the Cameron collection was published by the National Portrait Gallery in 1975 and dedicated to Helmut Gernsheim, Sam Wagstaff and the 4,000 companies and individuals who helped purchase the collection for the nation. A thumbnail of Cameron's portrait of Herschel appears under Gernsheim's name, her Iago under Wagstaff's. A second cheaper booklet included a foreword by the Director of the National Portrait Gallery John Hayes, in which he stated that if a 'national photograph museum is established, it is the intention of the Trustees to donate the Herschel album to it'. When the National Museum of Photography, Film and Television was eventually founded in 1983, the Herschel album became one of the first items in its collections.

Following the loss of Iago, Wagstaff quickly consoled himself with the acquisition of a major tranche of material by the nineteenth-century French

photographer Nadar and in his deepening relationship with the young photographer Robert Mapplethorpe. The two fed their mutual passion for photography: Wagstaff the collector and Mapplethorpe the artist. The nineteenth-century material that Wagstaff so loved – death and dying, sensuality and the inscribed identities created by the best portraitists – profoundly influenced Mapplethorpe's work. There is a striking similarity between the Iago portrait and the way in which Mapplethorpe presented both himself and Wagstaff to the camera's scrutiny. His *Self-Portrait in Leather Jacket* 1981 and portrait of *Sam Wagstaff* 1979 share the same look of sucked-in cheeks, brooding introspection and wide, closed lips. Indeed, *Self-Portrait in Leather Jacket* mimics Cameron's technique of making the lips the point of sharpest focus. It is also similarly lit, and the dark shirt and leather jacket of the title echo the black velvet drape with which Cameron swathed her Iago.

Colarossi's appearance in a studio under intense summer light, so different from the muted pale grey tones that Cameron tended to favour, obviously enchanted and inspired Mapplethorpe, and her works have sent a whisper of desire rippling down a whole line of practitioners, collectors and curators. Thus this complex and ambiguous photograph continues to secure the welcoming cultural embrace that Cameron had so earnestly desired for photography.

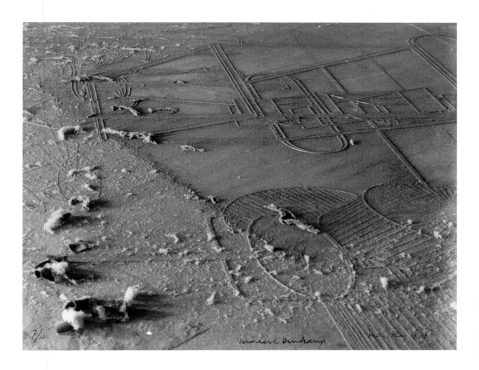

Man Ray and Marcel Duchamp
Dust Breeding 1920

By David Campany

It's my dream. A world where all would be silent and still and
each thing in its last place, under the last dust.
—Clov in Samuel Beckett's *Endgame* (1957)

Photographs sometimes work upon us very slowly, their resonance building
over time. For a decade or so I have circled around one photograph more
than any other. When I first saw it – I cannot even remember the occasion
– it made no immediate impression on me. There was no flash of recog-
nition, no deep connection. But it is an image with which I have had many
encounters in various settings and it has crept up on me.

Elévage de poussière (Dust Breeding) is attributed to Man Ray and
Marcel Duchamp. It has had an unusual life, and its origins were also
unusual. In 1920 a very young Man Ray was asked by Katherine Dreier to
photograph some of her art collection. She was planning to set up a new
museum. It was not something Man Ray had done before and he was far
from enthusiastic about the task. 'The thought of photographing the work
of others was repugnant to me, beneath my dignity as an artist', he declared
in his memoir. But he was keen to please and he set a date.

In the meantime he went to the studio of Marcel Duchamp on New
York's Broadway, where a sheet of glass, covered in dust, rested on saw-
horses. Duchamp had been cultivating the dust as a stage in the making of
what later became his great work *La Mariée mise nu par ses célibataires, même*
(The Bride Stripped Bare by her Bachelors, Even), commonly known as
The Large Glass, 1915–23. The dust would eventually be wiped away from
all but a key area, where it was fixed in place with clear varnish. When Man
Ray told Duchamp about Dreier's request, Duchamp suggested he practise
on the dust. His camera was duly positioned, and the daylight was sup-
plemented with a bare electric bulb. The shutter was opened and the two of
them went for lunch. After about an hour they returned and closed the
shutter. Man Ray developed the sheet of film that night. 'The negative was

perfect', he stated. 'I was confident of the success of any future assignments.' The image bears little resemblance to the functional photography of paintings or sculptures that we associate with inventories and catalogues, and it can hardly be thought of as a technical test or apprenticeship. It is too odd, too singular.

The original negative shows the edge of the dusty glass and a little of the studio beyond. Man Ray cropped it down, removing the spatial certainty, letting it become a separate world. The first publication of the image played on this. In the October 1922 issue of the French Surrealist journal *Littérature* it is attributed to Man Ray and accompanies an article about Duchamp written by André Breton. This is early in the history of Surrealism, so early that it may make *Dust Breeding* the first Surrealist photograph. It was captioned *Voici le domain de Rrose Sélavy. Comme il est aride – comme il est fertile / comme il est joyeux – comme il est triste! Vue prise en aéroplane Par Man Ray 1921* (Here is the domain of Rrose Sélavy. How arid it is – how fertile it is / how joyous it is – how sad it is! View from an aeroplane By Man Ray 1921). Aerial reconnaissance photos had entered the popular imagination with the First World War. Rrose Sélavy was a more obscure reference. She was the female figure invented by Duchamp as a second persona, muddying any idea of the singular, masculine artist. Already the photograph had become doubly ambiguous. Dusty glass alternated with an aerial view; Man Ray alternated with Duchamp and his alter ego.

Dust, like water, is an enemy of photography. It might be photogenic but it needs to be kept at a distance. Dust is a trace – a trace of mortality. A photograph is a trace of what was before the camera. So a photograph of dust is a trace of a trace. In this sense *Dust Breeding* emphasises what is known in semiotics as the photographic 'index'. Traditionally defined, an index is a sign caused by its object. For example smoke is an index of fire because it is the burning wood; a footprint in mud is an index of the foot. Similarly, light bouncing off an object registers on a light-sensitive surface, and thus the photograph obtained is the index of that light. However, a photograph is an index in another sense too. It is an indication of the presence of a camera or vantage point. Looking at the Man Ray/Duchamp image we may be unsure what we are looking at and from where we are looking. So we turn to the title. 'Dust breeding' gives us information. It describes the stuff in the picture and implies the distance of the lens from the object. 'View from an aeroplane' gives information too, but it works differently. It indicates a false vantage point and leaves it to us to deduce what the subject matter might be.

Micro or macro, *Dust Breeding* resembles, to borrow the French title of another Man Ray image, a *terrain vague*. It looks like a waste ground or disused area, perhaps the overlooked edge of a city. It is an indoor image alluding to the outside, particularly when titled 'View from an aeroplane'. Modern Europe saw the *terrain vague* as a site of anxiety: 'I will show you fear in a handful of dust' warned T.S. Eliot in *The Wasteland* (1922). In North America there is more *terrain vague* than anything else. There, it appears more as a motif of boredom or entropy. Dust has a place in both schemes. It is abject, liminal, bodily stuff that threatens the modern and rational order. It is also a sign of dead time passing. The photograph was made in America, but the dust had been gathering in Duchamp's absence while he was staying in his native France. The American Man Ray made the picture and took it to Europe, where it appeared in print in the different spatial order of Paris. All of this may have been on his mind, because around that time he made another image looking down at detritus which he called *Transatlantic*.

As a *terrain vague* the photograph bears a striking resemblance to an image made by another European in America. There is a famous scene in Alfred Hitchcock's *North by Northwest* (1959) in which a desolate plain is observed from above. It is timeless and airless. There is no horizon, just a single road across the frame. A bus drops off a solitary man in the expanse. Out of a blank sky an aeroplane arrives to terrorise him. It sprays him with toxic dust meant for crops. 'Every place', said Hitchcock, 'is potentially a scene of a crime no matter how harmless or meaningless it appears to be'. For him, American space was as anxious as it was entropic and this is what makes the scene so tense. Like *Dust Breeding* it is all about the uncertainties of identity: Cary Grant, born Archibald Leach, plays the advertising executive Roger Thornhill, who is mistaken for a spy called George Caplan.

In 1935 the photograph appeared once more, this time as a backdrop on the cover of the Surrealist journal *Minotaure*. The main motif was one of Duchamp's *Rotoreliefs* – his circular discs with spiral designs intended to spin for optical effect. *Dust Breeding* can be glimpsed behind. It is not given a title or even mentioned. Ten years later it was again used as a backdrop, this time behind the poem 'Flag of Ecstasy' by Charles Henri Ford, in an issue of the American magazine *View*, dedicated to Duchamp. Ford's verse praises Duchamp to the heavens, elevating him rather grandly above earthly art: 'Over the towers of autoerotic honey / Over the dungeons of homicidal drives'. On the page the words float over the photograph's aerial view. Both publications carried André Breton's account of Duchamp's *The Large Glass*. This was the essay that began the securing of Duchamp's

erratic reputation, but it was not all Breton's thinking; he drew on Duchamp's own cryptic notes issued in 1934 as the *Green Box*. This was a loose collection of facsimiles of handwritten fragments and drawings. Also included was a reproduction of *Dust Breeding*. Much more than a supplement or set of anecdotes the *Green Box* is an integral part of *The Large Glass*. No clear separation can be made between the artwork and its commentary, such is its enigma and complexity. Together they are a machine for generating meanings. In 1949 Duchamp was clear: *The Large Glass* 'should be accompanied by a text that is as amorphous as possible and never takes on a definitive shape. And the two elements, the glass for the eye and the text for the ear and the mind should not merely complement each other but should above all each prevent the other from forming an aesthetic-visual unity.' In *Littérature, Minotaure, View* and the *Green Box, Dust Breeding* is embedded in a dense weave of images, thoughts, ideas and associations. There is no tugging it free to make sense of it on its own terms. To get out you have to go in deeper.

For all its indeterminacy *Dust Breeding* has a realistic dimension too, rooted in the base materialism of dust. In conventional accounts of photographic realism it is the overlooked, the incidental details, that underwrite its claim to truth. Roland Barthes called this the 'reality effect' – the camera exposure takes in the wanted and the unwanted all at once, without discrimination. The mechanical indifference of the optical image, its ability to 'see' without hierarchy, was what distinguished photography from the outset. Indeed dust, that lowly, almost invisible substance, crops up in the earliest commentaries on the medium. In 1839 the English physicist Sir John Robison said of Talbot's first photographs: 'A crack in plaster, a withered leaf lying on a projecting cornice, or an accumulation of dust in a hollow moulding of a distant building, when they exist in the original, are faithfully copied in these wonderful pictures.' The difference is that *Dust Breeding* turns photography's background condition into the main subject. This dust is not 'matter out of place'. It is willed, encouraged, *bred*.

Modernist photography, particularly in North America, had at its heart a paradox. It was preoccupied with a quality of the world that the photograph conspicuously lacks: texture. As the surfaces of the modern world became ever smoother, photography retained a fascination with the extremes of texture. The gleaming facades of the modern city and the crumbling, cracked hands that built and maintained it offered themselves up to a lens fascinated by both. As Edward Weston, the high priest of the photographic surface put it: 'The camera should be used for a recording of life, for rendering the very substance and quintessence of the thing itself,

whether it be polished steel or palpitating flesh.' Let us not forget here that beneath the flaky surface of *Dust Breeding* is smooth industrial glass.

The play between the roughness of the weathered world and the surface (or surfacelessness) of the photograph is also a play between two notions of time. The slowness of the world's attrition, erosion and deposition contrast with the sterile, immaculate conception of the camera image. The settling dust on Duchamp's glass created a textured, opaque surface. It was later fixed by varnish as a smooth, permanent translucence. The process of fixing the fallen dust and sandwiching it between glass plates in the final form of *The Large Glass* is quite photographic. *Dust Breeding* is an extraordinarily self-reflexive image of photography understood as a trap for the incidental.

Trapping incidents became an important strategy early on for Duchamp. Among other things it helped him make art that downplayed the mark of the artist's hand. 'Canned chance', he called it. It is not, of course, that allowing a substance to fall will eliminate entirely the role of the maker. Think of Jackson Pollock's drip paintings. Gravity was no longer depicted exerting itself upon objects in representational painting. Instead it became an active element of the painting as process. The receptive surface became a repository of events. Perhaps we can see a connection between *Dust Breeding* and the famous photographs from 1950 of Pollock working on canvases on his studio floor. In each we look obliquely at a horizontal surface as it receives its marks. Their function is similar too, since each works at the level of the anecdotal document intended for publicity.

The full impact of Duchamp's art took a long time to penetrate. In many ways his insights seemed too complicated for the art culture of the inter-war years. Everything he did connected with everything else and there was no pretence at making singular, autonomous art works. Not until the 1960s, when vanguard art was turning away from the reductions of abstraction to 'dematerialise' into process, documentation and performance, did his approach seem prophetic. *Dust Breeding* was caught up in the delay: it is the dust swept under the carpet of purist modern art, only to be uncovered by Conceptual art.

In 1970 the photograph was given another audience. New York's Museum of Modern Art put on *Information*, a large survey show that attempted to predict the artistic concerns of the decade to come. This was the first major exhibition to showcase the emerging Conceptualism that was preoccupied with art as data collection and experimentation with forms of evidence. The catalogue included a set of keynote images. One of these was *Dust Breeding*, reproduced as a full page. A photograph made half a century earlier now heralded radical contemporary innovations.

Many Conceptual artists relished the double relationship that photography has to form. As an apparatus, the camera is always on the side of the formal and the rational, but it can preserve the formless and ephemeral. Instead of making an object, one could perform an action and document it through a photograph. Bruce Nauman, for example, might shape a heap of flour into various forms on his studio floor and photograph it as he goes along. The photograph becomes a sign to focus our attention on transient or minor things. (In 1920 Duchamp had hung a sign on his studio wall that read 'Dust Breeding: To Be Respected'.)

Dust Breeding exploits the fact that photography has always had two roles in art. On the one hand it is an art form, on the other it is the functional means by which all art forms are documented and publicised. In the 1920s, photographic reproduction was beginning to transform the entire culture of art. The ability to turn all art into photographic images would have a far more wide-ranging consequence in the form of fine art publishing than any artistic photography. Perhaps Man Ray was aware of this in his gut reaction against photographing artworks.

Mulling over this duality in 1928, the cultural critic Walter Benjamin pieced together a set of binary pairs. They included: 'The artist makes a work / The primitive expresses himself in documents'; 'The artwork is only incidentally a document / No document is as such a work of art'; 'The artwork is a masterpiece / The document serves to instruct'; 'On artworks, artists learn their craft / Before documents, a public is educated'. *Dust Breeding* belongs to the oeuvres of both Man Ray and Marcel Duchamp as distinct artists. It also belongs to a joint body of work. Do we read the image as an artwork in so far as it is by Man Ray, then as an artless document in so far as it is by Duchamp, author of *The Large Glass*? Perhaps one cannot answer this in a clear-cut way. But the tension between artwork and document is there, just as it is there at the core of nearly all the shades of debate about photography's merit as art. Of course, the debate was not in the end decided in this 'either/or' manner. Through the conceptual strategies prefigured by *Dust Breeding*, photography ultimately triumphed by flirting with automatism, with being an artless document. Andy Warhol's use of archival news pictures in his silkscreens, or Bernd and Hilla Becher's flat, neutralised photographs of industrial architecture are examples of this. In other words photography became central to art at the very point when art was asking: 'What is art and what is its relation to what isn't art?'

In 1989 I saw *Dust Breeding* in one of the many shows that celebrated 150 years of photography. There it was, this odd-looking photograph, conventionally window mounted, hanging quietly in London's Royal

Academy, which was trumpeting the official acceptance of the medium as art with a grand exhibition. However, this was an image that had antici-pated not the pompous arrival of photography through Art's great gates but its sneaking in the back as a slippery, unreliable, mercurial medium. Dada, Surrealism, Pop, Conceptual art – photography was central to them all, but none of them had elevated it as an 'independent art'. *Dust Breeding* embodies so many of the formal ambiguities and expanded possibilities of what an artwork can be. In this single photograph there is an exploration of dura-tion, an embrace of chance, spatial uncertainty, confusion of authorship, ambiguity of function, and a blurring of boundaries between media – photography, sculpture, performance.

Now *Dust Breeding* is eighty-five years old and its place in our current understanding of things is different. Is there not something resonant in the resistance to all things fast in this image? *Dust Breeding* refuted the instan-taneous. It denied the quick snap of the shutter that came to dominate the medium's relation to modern time. Its exposure was made over a leisurely lunch, not in the blinking of an eye. Its subject matter is the epitome of all that is slow. Today photography's romance with speed is all but over. The 'decisive moment', the art of the caught photograph, seems like a distant chapter. Where photography was once the medium of moments, it now appears as a deliberating, forensic medium of traces. Overshadowed by television, video and the Internet, photography is coming to terms with its relative primitivism. It is becoming a leftover medium for, among other things, leftovers. The dust of progress will go on breeding and perhaps photography will be there to record it.

Bill Brandt
A Snicket, Halifax 1937

By Nigel Warburton

Bill Brandt's photograph of a cobbled lane (or 'snicket') in Halifax has a haunting beauty. Like many of his photographs of the 1930s, it serves two very different aims. On one level it documents part of an industrial town in a bold but simple style consistent with its subsequent publication in the popular magazine *Lilliput*. At another, it constructs a dreamscape that Brandt would place within his artistic oeuvre. This combination of the found and the imagined was Brandt's distinctive contribution to photography. His work was rarely either purely documentary or extravagantly pictorialist, but lay somewhere in between.

Formally, the image is simple: strong converging lines made by the walls and handrail on either side of a steep path take the eye up to a small expanse of white sky crossed by electricity cables. Brandt's reductionist printing style has imposed further abstraction. The texture of the gleaming cobbles contrasts with the pure sheen of the walls. In the version illustrated here, which comes from a print made some thirty years after Brandt's visit to Halifax, a smudge of dark smoke hangs over the silhouetted mill alongside the path. In the second edition of *Shadow of Light* (1977), Brandt's definitive reinterpretation of forty-five years of his photography, *A Snicket* was paired with a shot of children running alongside a railway track by the 'catch point', dwarfed by Halifax's industrial chimneys. The smoke from this image seemed to drift into the right-hand image, while the diagonal of the railway lines on the left is balanced by those of the snicket on the right. Small wonder that Brandt has been called a formalist in photography, a label that captures the surface interest of many of his cityscapes. Yet his deserted streets owe as much to his early immersion in the world of Surrealism as they do to geometry. He had worked in Paris as Man Ray's assistant between 1930 and 1934, and, though never an official member of the Surrealists, adopted a recognisably Surrealist attitude to the world he depicted. He had also originally wanted to train as an architect, and although prevented from doing so by ill-health, nevertheless remained unusually

sensitive to the built environment, and in particular to the empty street, to factories, chimneys, bridges and ruins. The mill, stained with soot from the railway, and the moist cobbles of the lane were the ideal raw materials for this magical transformation of an unpromising site.

Brandt described his photography as a quest to achieve *atmosphere*. He defined this memorably as 'the spell that charged the commonplace with beauty'. The source of atmosphere need not itself be pleasant or attractive. In this case the path had little obvious beauty, nor was it especially unique. In the 1930s there were many other cobbled snickets in Halifax, though most of these have now gone. But in the photograph, the steep, deserted lane seems charged with mystery. It is a classic example of atmosphere achieved through subtraction. Brandt's images always emerged from dark-room transformations, and here he has printed in a way that pared the scene down to its essence. By removing all extraneous detail from the walls on right and left, and most from the mill, as well as emphasising the lines of the handrails, he endowed a real place with a timeless and surreal quality. This subtraction was not just visual, but to some extent political. In that lies a tension.

Brandt's process of selection and intensification of atmosphere are best understood in relation to the actual site of the photograph. What is not obvious from the image is that the snicket leads up to a footbridge over the railway; on the other side of the snicket are steep steps. The path presumably allowed horses as well as people to cross the railway. The small square visible at the top of the slope is the beginning of the bridge. On the right is a wall between the path and the tracks. The mill building on the left, surprisingly, extends back for perhaps fifty metres. This is part of the immense Dean Clough mill that was once one of the largest carpet manufacturers in the world but now houses offices and an arts centre. When it was in full production, several thousand people worked there. Brandt's selection disguises the scale and activity of this building, concentrating on the two-dimensional shape of its cross-section. There are very few angles from which it is possible to picture it without revealing its depth: Brandt's clear choice was to use the building as a two-dimensional shape rather than as a solid. The unsettling converging walls, an artifice of the camera angle and lens, would not look out of place in a German Expressionist film such as Robert Wiene's *The Cabinet of Dr Caligari* (1919). It was from the top of this snicket that Brandt had photographed children running towards him alongside the tracks and dwarfed by three chimneys. This reveals the pairing of *A Snicket* with the catch-point photograph as more than merely formal. It also explains the source of the smoke above the mill building,

which might seem to have come from a second negative, but almost certainly drifted in from the tallest chimney some distance behind.

Sizing up the scene, Brandt probably held his Rolleiflex camera at waist height and looked down onto the ground-glass screen to focus, giving him the low angle of vision that enhances the effect of the mill looming over the pathway. It was this camera position that would have helped him to recognise the atmosphere of this location. He probably had to crouch or use a very low tripod to give the impression of the path rising so steeply. This also allowed him to present the left-hand wall as a strong diagonal: if he had positioned his camera further back, or higher up, a change in the angle of the wall at the bottom of the path would have become visible, and the force of the straight diagonal diminished. Most of the drama of the image is the result of Brandt's selections and subtractions. His choices reduced all that was in the frame to two basic architectural elements: the path and the mill.

Brandt took the picture during a journey north in 1937. This was one of several trips he made to Newcastle, Durham, Sheffield and Jarrow during which he produced some of his finest pre-war work. His first book, *The English at Home*, which was predominantly about Londoners and those living in the South East, had been published the year before. At least one reviewer had seen its juxtapositions of wealth and poverty as politically charged, and argued that Brandt had almost bludgeoned the viewer with a socialist message. However, Brandt later made clear where his primary concerns lay at that time: 'I was probably inspired to take these pictures because the social contrast of the 1930s was visually very exciting for me. I never intended them, as has sometimes been suggested, for political propaganda.'

In spite of this comment it would be wrong to see Brandt as a cold aesthete using poverty and industrial grime as the means to purely visual ends. His original motivation for his journeys north came from his sympathy for the plight of the Jarrow Marchers, who had arrived in London in 1936, and from his reading of *An English Journey*, J.B. Priestley's personal and critical memoir of travelling through England in the autumn of 1933. Priestley had written of the human effects of unemployment during the Depression, and of the social fabric of these Midland and Northern towns that was in danger of disintegrating. Brandt knew the cause – 'a terrible lack of direction and leadership in our affairs' – but his images fall short of taking an overtly political stance. His journeys north did not produce the visual equivalent of George Orwell's *The Road to Wigan Pier* (1937), though several of the images of miners are comparable

with the photographic illustrations in the first edition of that book. In the specific details of workers' lives and surroundings, Brandt found universal and symbolic qualities that epitomised a time or a place, or even transcended the historical moment. Yet when *A Snicket* was first published it did not preclude a political reading.

It would be more than ten years before Brandt published the image. It appeared in a six-photograph sequence entitled 'Hail, Hell and Halifax' in the February 1948 edition of the small-format mass-circulation magazine *Lilliput*, a major source of employment for Brandt throughout the 1940s. At this time most of his artistic work emerged from commissions, many given to him by *Lilliput* editors Tom Hopkinson and Kaye Webb, both of whom greatly admired his photographic style and nurtured his talent. He published over thirty features there, including landscapes, portraits and cityscapes. The title of the *Lilliput* feature, 'Hail, Hell and Halifax', picked up in the short text by J.P.W. Mallalieu (later Labour MP for Huddersfield East), deliberately misquoted a Yorkshire proverb: 'From Hull, Halifax and Hell, good Lord deliver us'. This proverb also features as the refrain of a Yorkshire dialect song 'A Dalesman's Litany' about the vicissitudes of industrial life. It begins:

It's hard when fowks can't finnd their wark
Wheer they've bin bred an' born;
When I were young I awlus thowt
I'd bide 'mong t' roots an' corn.
But I've bin forced to work i' towns,
So here's my litany:
Frae Hull, an' Halifax, an' Hell,
Gooid Lord, deliver me!

Four of the six photographs in the *Lilliput* feature are of industrial chimneys billowing out heavy clouds of smog. They echo the sentiments of the song. Only two include people – mainly children. The other four present a town of mills, warehouses, factories, smoke and soot. The children play beneath skies laden with industrial waste, an effect exaggerated by the darkness of Brandt's printing. Mallalieu's caption for the snicket has the tone of a fable, and forces a sombre reading with a latent political message:

Men, too, have struggled for a foothold. Up this 'ginnell' or 'snicket' or 'nicket' they clamber, frozen fingers grasping an icy handrail. In the old days of iron-shod clogs, you took one step

forward and slid two steps back. Even today, with the clogs discarded, only the youngest can make these climbs without a pause for breath. The children have something to climb for. But the older ones know there will be little pleasure on the other side.

Yet the image that accompanied this text in *Lilliput* was not as bleak as the one shown here. The mill building to the left of the snicket was not a dark block, but had visible windows and doors. There was a greater expanse of white sky showing at the top of the hill, and no smoke. In later years Brandt intensified the image by degrees: progressively darkening it both literally and metaphorically until by the second edition of *Shadow of Light* the factory front was a completely featureless block. This schematic presentation is how he preferred exhibition prints of the image to appear. The smoke could have been added from a second negative, but it is more likely that it had been suppressed in the *Lilliput* version of the print. The handrails might have been drawn in with white pen. The variants of *A Snicket* moving in the direction of increased abstraction provide an example of Brandt's approach to the creation of atmosphere. In the two editions of *Shadow of Light* and in his printmaking for artistic exhibitions he reinterpreted his earlier work, homogenising its printing style and in most cases simplifying the elements of work that had originally been made on photojournalistic commissions. His aim was to reveal the latent magic of the commonplace in the process of printing and manipulating the image, so that the eventual viewer of the picture would be transported to a world beyond mere appearance. Brandt saw any form of enhancing the image as legitimate. As he put it: 'Photography is not a sport. I believe there are no rules in photography. A photographer is allowed to do anything, anything, in order to improve his picture.'

It was relatively easy for the British artworld of the 1960s to acknowledge Brandt as a photographic artist since his individual style was immediately recognisable both from the point of view of his printing and of the dream-like world that his images depicted. His pre-occupations were recognisably artistic and accessible to curators trained in the history of painting. The writer Ian Jeffrey has characterised Brandt's later prints well:

It was as if they had all been taken, these canonical pictures, in one fabulous excursion through an extended Symbolist twilight. Their relatively large scale and emphatic shadows and highlights declare them to be prints rather than photographic records. They sidestep

insistent questions regarding site and time, as they imply a kind of finality. You need look no further, they declare, concluding with a flourishing signature; like certificates authenticated.

By the time of Brandt's landmark retrospective exhibition at the Hayward Gallery, London, in 1970, he had long ceased to think of himself as a photojournalist. By signing the front of his prints he revealed his desire to be recognised as an artist. And critics readily responded to him as a poet, recognising the metaphorical aspects alongside the referential in his work. In a 1966 review of *Shadow of Light*, John Berger wrote: 'In a picture like *A Snicket in Halifax* its power as a metaphor for an enforced way of life (uphill, bleak, dimmed, counted in pennies or cobbles) is due to Brandt's imaginative identification with the place.'

The path as metaphor is important in at least two other key Brandt images: his photographs of the Pilgrims' Way in Kent, and his more famous portrait of the painter Francis Bacon on Primrose Hill. In the first of these, the line of a narrow path through grass, like *A Snicket*, relies on a strong diagonal and the reduction to basic elements. The portrait of Bacon also echoes the composition of *A Snicket*, with the path receding to the right and the figure occupying and dominating the left. Bacon's shoulders even replicate the pitch of the mill roof. It is as if the afterimage of *A Snicket* imposed itself as a template for another of Brandt's iconic photographs.

Although recognisably linked to a particular place, *A Snicket* related as much to Brandt's inner vision as to the external world. He had been psycho-analysed by Wilhelm Stekel, a pupil and former analysand of Sigmund Freud, and seemed peculiarly attuned to the symbolic power latent in the world he photographed. Indeed Brandt's photographic transformations are analogous to some of the primary processes of the psyche by which, according to Freud, our unconscious wishes are presented in dreams in symbolic forms. This might go some way to explaining the dream-like quality of Brandt's depicted world. At a stretch, the mill could be seen as a phallic symbol. The smoke would then take on a new significance. According to Freud, hills too, often feature in dreams as references to the male organ. This is not to suggest that Brandt consciously sought out these symbols, but that such elements may be familiar contents of our dream worlds that he recognised at an unconscious or at least pre-conscious level. In his photographs these elements are simultaneously familiar and strange. They originate in our ordinary everyday experience, yet seem to stand outside time and resonate with mystery. This aspect of Brandt's work legit-imates the use of the label 'surrealist' which is often employed somewhat

loosely. As Max Ernst pointed out, the Surrealists did not strive to depict the content of dreams. Rather 'they freely, bravely and self-confidently move about in the borderland between the internal and external worlds which are still unfamiliar though physically and psychologically quite real ("sur-real"), registering what they see and experience there'. No other photographer has so effectively occupied that borderland.

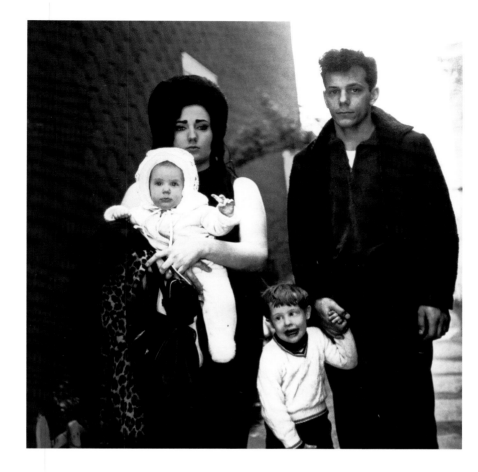

Diane Arbus
A young Brooklyn family going for a Sunday outing, N.Y.C. 1966

By Liz Jobey

The fictions we make about photographs are as unreliable as they are unavoidable. Not for the first time have I thought, looking at some of Diane Arbus's photographs, including this one, that they have their parallels in another art form, in literature, and particularly in the stories of Raymond Carver, about ordinary people whose lives, through some weakness, some internal flaw or force of circumstance, begin to fall apart, or are altered beyond all expectation. When you look at this young Brooklyn family about to set out on a Sunday outing, you can't help wondering what will become of them. Are they victims of some tragedy waiting to happen? Will they fight, separate, divorce, marry other people? Will they die an early death? Or will they live out the clichéd, doomed existence of a blue-collar couple in a Bruce Springsteen song? But first, more pertinently, why do we assume they are victims at all?

We pity them partly, with hindsight, for their compliancy. Why did they agree to be photographed in the first place? But we also think of them as victims because of the way they look. For all their apparent willingness to stand before the camera, the family looks benighted. The young man, protectively holding the hand of his little boy as if worried the camera might hurt him, looks shyly, politely towards the photographer, not smiling but watchful, nervous, as if he already realises he has gambled on her apparent friendliness and lost. His whole physical presence is tentative, a lightly poised figure in shades of grey compared to the solid, voluptuous presence of his wife, all black and white contrasts, with an armoury of self-protection clutched in front of her: the leopard-skin coat, the leatherette handbag, the camera case with the strap wound round her fingers crossing out her wedding ring, her bland white baby. She looks, in her make-up and her dress, as if she is beginning to preserve the style of her prime, which is already passing. But unlike her husband's, her gaze is directed into the middle distance, refusing to engage with the photographer. Hers is a bleak, faintly defiant, almost trance-like expression, as if she has emptied her

mind for the purpose of the process in hand. Her son, probably under orders to stop wriggling, is plainly in distress, looking round wildly and clutching his groin (a gesture echoed by his mother's hold on the baby), as if he understands that something odd is going on but isn't quite sure what. Only the baby, as is its prerogative, gazes out into the future, unperturbed.

In posing for the traditional family shot, they have unwittingly undermined all the positive values that formation represents. Instead they have handed the photographer something much more important, a contemporary metaphor: the unhappy family snapshot. Forced to look straight ahead, forbidden to smile, the pose encourages separation rather than cohesion, and it tempts us to translate appearance into character: his weakness; her frustration. The overriding emotion is one of disappointment. They look, or their marriage looks, already exhausted. It was this, presumably, that prompted Arbus's recollection of them, in a comment that has always seemed almost as memorable as the portrait itself: 'They were undeniably close in a painful sort of way.'

She wrote this two years later, when the photograph was about to be published in Britain, in a special 'Family Issue' of the *Sunday Times* colour magazine. The feature was titled: 'Two American families'. (The second portrait was of an affluent Westchester couple sunbathing on their lawn.) Both photographs were by Arbus, and the short text that went with them was also credited to her. In fact it had been put together from the contents of a letter Arbus had written to Peter Crookston, the magazine's deputy editor. 'They live in the Bronx. I think he was a garage mechanic. Their first child was born when she were sixteen … They were undeniably close in a painful sort of way.'

It's that word 'undeniably'. If you remove it, the phrase loses its sting. But 'undeniably' has a patronising air, as if, in her judgement, under the circumstances, genuine closeness between the couple was impossible. Why? Because they are overstretched by the demands of an early marriage, straight out of high school, with a retarded child and a baby to care for? Because they had argued the night before and hadn't made it up? Because they were nervous in front of the camera and Arbus had mistaken this for some intrinsic problem within their marriage? Were they ashamed of their boy, or how he might look? We will never know. We have no evidence of how they behaved, or how they really felt about each other; no other information except that attractively phrased snap judgement made by a stranger. But once they had given themselves up to the camera, there they were, pinned to the wall and labelled forever: 'undeniably close in a painful sort of way'.

There are some facts. Their names are Richard and Marylin Dauria. Richard is an Italian immigrant and works as a car mechanic. They met in high school and were married when Marylin was sixteen. She is now twenty-three. They have three children; the two pictured here are Richard Jnr, who is mentally retarded, and the baby, Dawn. Marylin is often told she looks like Elizabeth Taylor. She dyes her hair black to make herself seem Irish, which she is not. (We don't learn why she wants to be thought Irish, but perhaps it's because the combination of blue/grey eyes and jet-black hair, is typically Irish, and also typically Tayloresque.) Crookston left out the bit about their first child being born when she was sixteen, which suggested a hasty marriage soon before or even afterwards. But more inter-estingly he modified Arbus's comment about their closeness. In the magazine, his version read: 'Richard Jnr is mentally retarded and the family is undeniably close in a painful, heartrending sort of way'. The feeling of pain has been shifted from the couple to the photographer. Which was correct? Did Arbus accurately detect a painful closeness between them, or was it she who felt the pain, observing them together? (Afterwards she wrote to Crookston to complain about the text: 'next time let me write it so it makes more sense'.)

By 1968, when the Brooklyn picture was published in Britain, Arbus had gone from relative anonymity to relative fame. In February 1967 thirty-two of her photographs had been included in an exhibition at the Museum of Modern Art in New York, along with those of two of her contemporaries, Lee Friedlander and Garry Winogrand (each was given a space of their own). All three worked as street photographers, but as John Szarkowski, head of the department of photography at MoMA, explained in his intro-duction to the show:

> In the past decade a new generation of photographers has directed
> the documentary approach to more personal ends. Their aim has
> been not to reform life, but to know it. Their work betrays a
> sympathy – almost an affection – for the imperfections and the
> frailties of society … What they hold in common is the belief that
> the commonplace is really worth looking at … The portraits of
> Diane Arbus show that all of us – the most ordinary and the most
> exotic of us – are on closer scrutiny remarkable.

The photographs that first marked Arbus out for attention in the early 1960s were portraits of the people she referred to as 'freaks', men and women living on the margins of society because of their physical or mental

or sexual difference. They included midgets and giants, circus performers and drag queens, faith healers and mystics, each of whom she sought out and persuaded to pose for a photograph. But although they were all in some sense extraordinary and 'different', it wasn't this that made her photographs disturbing, it was the way she photographed them; it was the way they engaged. Mostly they were single portraits, and some couples – twins, lovers, friends. She shot them as three-quarter figures, with little surrounding detail, and in every one the person photographed looked straight back into the camera, with a direct gaze that was unsettling in both its passivity and its wilful surrender to the act of being photographed. Their very deliberate full-frontal stance suggested an unusual complicity between the photographer and her subject. It raised questions, not often raised so worriedly in photography, about the nature of the encounter, and the motivation of the person behind it.

Arbus employed the approach of the street photographer (an approach that, partly because of her photographs and the copycat stylists it engendered, is almost impossible today); that is, she walked the streets with her camera at the ready, searching for people whose appearance and attitude drew her to them. But her purpose was not philanthropic in the conventional sense. Something in her own psychological make-up made her seek these people out and proposition them. She thought she saw a quality, a difference, worth recording. 'It's what I've never seen before that I recognize', she said. 'I really believe there are things nobody would see if I didn't photograph them.' For one of her first published magazine features she sought out and photographed five eccentric New Yorkers (they included Jack Dracula, the tattooed man, Miss Cora Pratt, 'the counterfeit lady' and William Mack 'the sage of the wilderness'); they were, she explained, 'five singular people who appear like metaphors, somewhere further out than we do ... so that we may wonder all over again what is veritable and inevitable and possible and what it is to become whoever we may be.'

The 1967 MoMA exhibition brought her welcome public recognition, but it also brought problems. According to Szarkowski, she worried it came too early: 'what she was doing was quite different from what other photographers were doing, and she wanted a chance to complete it ... before getting it out in public'. She also wanted to make sure that her pictures were made public in the right way, so that they didn't appear to be 'in violation of her personal, moral commitment'. She needed the permission of her subjects to publish and exhibit them, and it was not always easy to get. In 1966 she sought legal advice, 'because my photographs are becoming more and more questionable'.

This balancing act, between pursuing the kind of subject matter that most engaged her, and making a living from her pictures, continued throughout her working life. She was always keen to find magazine editors who would commission her to cover subjects that fed into her own personal agenda. When she heard of the *Sunday Times* special issue, she had other candidates. The first was 'perhaps too exotic … I know a Jewish giant who lives in Washington Heights or the Bronx with his little parents. He is tragic with a curious bitter somewhat stupid wit. The parents are orthodox and repressive and classic and disapprove of his carnival career … They are a truly metaphorical family.' The second provided the companion picture to the Brooklyn family portrait:

there is a woman I stopped in a Bookstore who lives in Westchester
which is Upper Suburbia. She is about thirty-four with terribly
blonde hair and enormously eyelashed and booted and probably
married to a dress manufacturer or restaurateur and I said I
wanted to photograph her with her husband and children so she
suggested I wait till warm weather so I can do it round the pool!

And, she added, 'I think all families are creepy in a way.'

The distrust of the family facade was based in personal experience. Her own family, she explained in a radio interview she gave to the oral historian Studs Terkel in 1968, was 'classic, upper middle-class Jewish, you know, second-generation American. My father was sort of self-made. He was something of a phoney. He could always appear to be richer than he was.' Her family owned Russek's, a fur retailers that in the 1920s expanded into a department store. She remembered 'the special agony of walking down that center aisle, feeling like the princess of Russek's: simultaneously privileged and doomed'. She had grown up feeling 'immune and exempt from circumstance. One of the things I suffered from was that I never felt adversity. I was confirmed in a sense of unreality … The outside world was so far from us, one didn't expect to encounter it. The doors were shut, as if there were some kind of contagion out there.' Later, she indicated that photography had been a means of escape: 'I think my favourite thing about photography … [was] I always thought it was a naughty thing to do … When I first did it, it was very perverse … suddenly it was a kind of license … [to] do exactly what I wanted to do.'

This idea, that photography allowed her to enter worlds forbidden to nicely brought-up Jewish girls, has caused speculation about her motives. Susan Sontag, who first wrote about Arbus in the mid-1970s, thought she

used the camera as a 'way of procuring experience, and thereby acquiring a sense of reality'. Her fascination with 'freaks', in Sontag's view, 'expresses a desire to violate her own innocence, to undermine her sense of being privileged, so [sic] vent her frustration at being safe'. Szarkowski thought otherwise. 'Her pictures', he wrote, 'are concerned with private, rather than social realities, with psychological rather than visual coherence, with the prototypical and mythic rather than the topical and temporal. Her real subject is no less than the unique interior lives of those she photographed.'

What is clear when you look at her pictures is that the 'freaks' seem better able to hold their own in front of the camera than the ordinary people. They were used to their differences; in many cases, like the giant, or the midget, they made a living out of them. What makes the photograph of the Brooklyn family so unsettling is the sense that the photographer is exploiting a much more private area, somewhere between doubt and defiance, between the feeling that it would be better to have refused her request and the feeling that, in fact, they deserved to be photographed. This area of slippage, this awkwardness, was what Arbus recognised the camera could capture.

Everybody has that thing where they need to look one way but they come out looking another way and that's what people observe. You see someone on the street and essentially what you notice about them is the flaw. It's just extraordinary that we should have been given these peculiarities. And, not content with what we were given, we create a whole other set. Our whole guise is like giving a sign to the world to think of us in a certain way but there's a point between what you want people to know about you and what you can't help people knowing about you. And that has to do with what I've always called the gap between intention and effect.

What is disturbing, looking at the photograph of the Brooklyn family, is the feeling that the couple have been trapped, whether by politeness, or by their own vanity, into agreeing to something that is out of their control. Perhaps Marylin Dauria, with her carefully orchestrated 'look', dreamed of some kind of fame; believed she might be 'spotted', and photographed and, despite her husband and three children, her life would change forever. But in the picture, her appearance (and her idea that she looks like a movie star) seems absurd, almost pathetic, whilst at the same time it presents a

compelling example of personal style. What we fear is that the Daurias have agreed to be photographed by Arbus but aren't up to the experience.

Each of Arbus's pictures was the result of a deliberately engineered encounter between herself and another human being, and the direct connection between herself and her subjects makes them appear complicit in the resulting image. We assume they have entered into the exchange freely; yet at the same time we know (because we, too, have been photographed), that to think you can predict how a picture will make you look is foolish, a guarantee almost that you will be betrayed. Maybe the Darais thought that in the hands of a professional, they would look better, rather than worse than they hoped. But Arbus understood that the camera was a dispassionate, uncivilised instrument; it made no allowances for the flaws and weaknesses it encountered, recording them faithfully, even if the result was disturbing, or upsetting, or just wrong.

Throughout her career Arbus sought out people who lived under the bar of success, celebrity and social ease. There were always people who, for whatever reason, were willing to stand before her camera, and so often in that moment they repaid her with a glimmer of human frailty; they fell victim to the uncertainty that assails us all at crucial moments of exposure. All photographs are historical documents, and as Sontag pointed out, a photograph confers importance on whatever is photographed. An Arbus photograph, though, is more than a record of a person at a certain time in a certain place; it is, more often than not, a record of a moment of personal anxiety, of a sudden identity crisis awakened and then captured by the camera. Whether or not what it shows is a true reflection of the subject's character is, from that point, irrelevant. The camera has made it so. 'The process itself has a kind of exactitude, a kind of scrutiny', Arbus wrote, 'that we're not normally subject to. I mean we don't subject each other to. We're nicer to each other than the interrogation of the camera is going to make us. It's a little bit cold, a little bit harsh.' And, as if she was finally admitting to something she had known all along: 'I think it does, a little, hurt to be photographed.'

In the thirty-four years since her death, no photographer has achieved the same peculiar intensity of response that she drew from her subjects. 'If I were just curious', she said:

> it would be very hard to say to someone, 'I want to come to your house and have you talk to me and tell me the story of your life.' I mean, people are going to say, 'You're crazy'. Plus they're going to keep mighty guarded. But the camera is a kind of license.

A young Brooklyn family going for a Sunday outing, N.Y.C. 73

A lot of people want to be paid that much attention and that's a reasonable kind of attention to be paid.

But is it? Sontag charged Arbus's photographs with a lack of compassion: 'For what would be more correctly described as their dissociated point of view, the photographs have been praised for their candour and for an unsettling empathy with their subjects. What is actually their aggressiveness towards the public has been treated as moral accomplishment.'

I have always wondered what the Brooklyn family thought when they saw their portrait. Were they pleased or disappointed or hurt by the result? Maybe Marylin didn't look as much like Elizabeth Taylor as she'd thought she did when she painted in her eyebrows that morning. Maybe Richard Snr felt as vulnerable as his expression suggests, though perhaps there is just the tiniest flicker of a smile in his eyes, as if he's thinking: 'At least this will be something to tell the guys about at work.' We know from accounts given by her friends that Arbus was a very persuasive person, who spoke, as she wrote, quirkily and with great charm. She accused herself of being 'kind of two-faced', when photographing people. 'I'm very ingratiating. It really kind of annoys me. I'm just a little too nice.' So whatever misgivings they might have had, the two of them stood there, looking ahead with what they perhaps felt was as little expression as possible, except that their faces are so expressive, and each one has a different reaction and a different emotion. For Arbus, a multiple portrait was rare, and in this case it was a rich reward. This was not only a picture about individuals and the gap between how they intended to look and how they looked, it was a picture about the family, about the distance between the ideal and the reality.

Though they have their place in photographic history, in what is one of Arbus's best-known photographs, I can't help wondering where Richard and Marylin Dauria are now. They would be in their early sixties. Their children would, perhaps, have children of their own. When they remember the day Diane Arbus took their picture, do they think: 'What did she see in us? *What did she want?*'

After Arbus's suicide in 1971, it was left to her daughters, particularly her elder daughter, Doon, to look after her mother's estate, which she has done, keeping a tight control over the use of images and the release of any archive material. It was only in 2003, with *Revelations*, a major retrospective of Arbus's work organised by the San Francisco Museum of Modern Art, that an enormous amount of archive material relating to Arbus's personal life was released for the first time. It took the form of a biographical timeline, compiled by Doon Arbus and the curator Elisabeth Sussman,

made up from extracts from her letters, her diaries and work books, her postcards to friends, snapshots, newspaper cuttings, letters from editors, curators, grant-giving bodies, even her autopsy report of 29 July 1971.

This chronology contributed to a greater understanding of the way Arbus worked. To any assumption that her subjects were principally one-time encounters, people she never saw again, *Revelations* issued a corrective. There were plenty of instances where she returned to photograph them again. Whether this was the case with the Brooklyn family, the chronology doesn't say. But looking in it, among the entries for spring 1966, there is another photograph of Richard and Marylin Dauria and their children, dated 15 May (which was a Sunday), taken in their living room. (The location is given as 'the Bronx home of a young Brooklyn family', which solves the discrepancy between the portrait's title and Arbus's description of where they lived.) Judging from what they are wearing, it was taken on the same day as the more famous portrait, but whichever picture came first, Arbus must have asked, or been invited, to go inside.

The photograph is taken from a greater distance, which shows some of the details of the surrounding room. Richard and Marylin are sitting on a sofa of modern design, its cushions covered in a flowered print. A kidney-shaped coffee table is at their knees and a large wall clock in the shape of a daisy hangs above their heads. To their left, a set of wooden shelves is balanced precariously on a couple of cardboard boxes to lift them higher. The bottom shelf is half-filled with books and the title that faces the camera is *Ideal Marriage*. Marylin is in black ski-pants, the straps looped under the heels of her black stilettos. Richard sits to her left, with the baby on his lap. Richard Jnr is sprawled across his mother's knees, making a dive for the baby, who is watching calmly as her brother heads towards her, his legs kicking frantically in the air, causing a blur of movement on the image. Both adults are looking straight ahead, as if oblivious to what is going on between the two children below.

The room is sparsely furnished, everything is modern and insubstantial. It betrays no sense of history, no sense of permanence; they might have moved in yesterday, or be gone tomorrow. It is an extension of the impression given by the family in their portrait: they have been trapped by the camera, but they are also trapped in their time, in the uncertain present.

Arbus was part of a generation of liberal Americans that was casting doubt on post-war optimism, questioning 'all-American' values – which included the country's political, military, racial and social policies. In protesting against Vietnam, in supporting civil rights, sexual liberation, feminism, pacifism, it amounted to a neurotic reassessment of America's

confident self-image. This scepticism and pessimism was apparent from the mid-1950s, in the photographs of Robert Frank, and later in films such as Bob Rafelson's *Five Easy Pieces* (1970), or in Joan Didion's essays, collected in *Slouching towards Bethlehem*, published in 1968. Didion described the place she found herself in: 'It was not a country in open revolution. It was not a country under enemy siege. It was the United States of America in the cold late spring of 1967 and the market was steady and the GNP high and a great many articulate people seemed to have a sense of high social purpose and it might have been a spring of brave hopes and national promise, but it was not.'

In place of optimism and confidence was a sense of alienation and rootlessness, a dislocation from the norm. Society was being scrutinised and the old orders were being challenged. In this new universe, losers could be heroes, freaks could be beautiful, ordinary people could be celebrities. If Arbus saw herself as an advocate for 'freaks', for people who were 'different', who were 'further out' than most of us are, she didn't feel it was her mission to introduce them into the mainstream. She valued them precisely because they managed to survive outside it. She didn't feel it her duty to provide Richard and Marylin Dauria with a photograph that reassured them they were just another happy American family. The last we know of them is that when Arbus had finished, 'they piled into their car to go to visit one of their parents'. It was an ordinary Sunday afternoon like any other. But her portrait tells otherwise; its power comes from the ordinariness they refute.

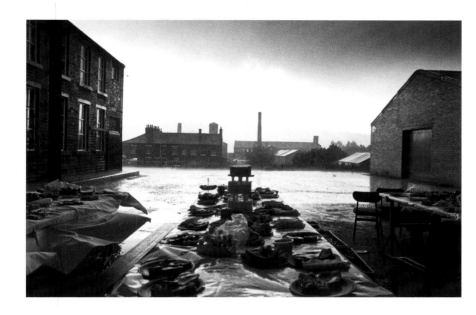

Martin Parr
Jubilee Street Party, Elland, Yorkshire 1977

By Val Williams

A sudden shower, a small ad in the *Halifax Courier* and a young photographer's interest in 'the ordinary' brought this memorable image into existence. Martin Parr's 1977 black and white photograph of an abandoned street party is part of an extensive body of work made in west Yorkshire in the mid-to-late 1970s. At the time he made the photograph, Parr had been living in Hebden Bridge for three years, and had become part of a growing artists' colony, many of whose members had been his fellow students at Manchester Polytechnic. In Manchester, he had developed a methodology of scouring the local press to find events, clubs and societies that might provide an arena for interesting documentary photographs. In the small Pennine towns and villages around Hebden Bridge, he found intimate and intricate communities, dominated by religion and their industrial heritage, and characterised by communal events and gatherings.

Apart from a photograph made in Epsom in the spring of 1975, *Jubilee Street Party* is the earliest photograph in the *Bad Weather* series, which Parr made in Yorkshire, Ireland, Manchester, London and Surrey from the mid-1970s to the early 1980s. In many ways it is typical of his work during this period, which often took the form of elegiac black and white portraits depicting everyday working-class life. By the time *Bad Weather* was completed, his picture-making had changed considerably, and he had begun to reject black and white photography in favour of colour, but this photograph was made several years before this radical shift in practice. For Parr, and many other photographers of his generation, 'reality' was pictured in black and white. They were taking their cue from the earlier documentary work of Bill Brandt and Walker Evans, as well as the more sardonic photographs by Tony Ray Jones, Garry Winogrand, Diane Arbus and Bill Owens made in the 1960s and 70s.

Like many other documentary photographers active in the 1970s, Parr was drawn to the Queen's Silver Jubilee because it signalled a reinvigoration of British working-class street life that was fast disappearing in a

country undergoing rapid social change. Since leaving the suburban South of England, he had become fascinated by chronicles of British working-class life epitomised by the soap opera *Coronation Street*, which depicts a close-knit, lively and often combative community whose arena is a Northern street of terraced houses. Throughout the 1970s, working-class people from the North of England were Parr's favourite subjects. He depicted a society that operated within well-defined codes of behaviour; it was quirky, amusing, reverential, dignified and quaint.

Parr had learned of the street party that was to take place in the mill town of Elland through the events section of the *Halifax Courier*. On the day he made the picture, he had already photographed another Jubilee celebration in the village of Todmorden. When he arrived in Elland, a sudden storm swept over the town, celebrations were temporarily abandoned, and Parr photographed the remarkable scene.

Jubilee Street Party says much about post-industrial West Yorkshire, a region grappling with a wide range of cultural and economic problems. The town's mill is dramatically visible in the background, its chimney seemingly higher than the Pennine hills behind it. Parr was acutely aware of the closing down of industry in this part of Yorkshire; in Hebden Bridge, artists were already moving into the rows of back-to-back houses formerly inhabited by mill workers. He had observed the aging population, which clung to traditional customs and habits, and was attracted to the decaying fabric of the Northern urban landscape. This industrial backdrop plays an important part in *Jubilee Street Party* – not only does it establish the exact location of the party, but it also reminds us of Britain's dying mills and growing unemployment. In this sense, *Jubilee Street Party* is a document of its times. It captures the spirit of a decade in which the citizens of the UK turned out in their millions to celebrate the reign of a monarch who was as distant from their lives as the emperor of some far off land. It was a decade in which British society was in flux, contemplating the modern, yet still firmly rooted in a traditional and conservative past. It was a time when Union Jacks were waved and party food was pork pies and pineapple chunks on sticks. The Yorkshire that Parr discovered when he settled in Hebden Bridge was a landscape of closure. But, as he observed, it was also a place where dignity and communality were highly prized, in which small events assumed great magnitude.

While much of Parr's photography from the late 1970s relied on his ability rapidly to compose photographs of individuals or groups in social settings, often focusing on leisure activities, worship or communal gatherings, *Jubilee Street Party* is one of a small body of photographs that employ

light, form and atmosphere to evoke a sense of ambiguity. It provides a near-perfect example of the way in which a photographer's art can create a feeling of illusion even while documenting the real world. The scene that we see in the photograph appears to be one of utter desolation. The tea is apparently soaked and inedible. The guests have fled to some unidentified place. It is as if a spell has been cast, causing all the people to vanish and the tables to become eerie sculptures. In fact, the party took place not in a street, but in a wider area, probably a factory yard, and although they appear to be in the open air, the tea tables had been placed under a high metal roof, not visible in the photograph. The food remained dry and the guests stood safe and unconcerned beneath the roof, towards the back of the building. This explains why the rain is pelting down in the background, but not at the front of the picture. When the weather cleared, the party would recommence, but the strength of this image, its sense of loneliness and enigma, makes such a situation hard to imagine.

The image exemplifies Parr's speed and opportunism as a photographer – the tablecloths on a side table catch a gust of wind at the moment when he presses the shutter, giving movement and lyricism to the somewhat austere composition. It also reflects his technical abilities with light and surface. The heavy shower, combined with light breaking through the dense clouds, gives the photograph luminosity, making this otherwise ordinary scene mysterious and mythic. The plates of sandwiches and sausage rolls, and the tiered and iced cake appear, in this moment of water and sunlight, as offerings to the gods, or, alternatively, bring to mind the deserted remnants of a meal on the ghost ship *Marie Celeste*. The light conditions resulted in a negative that has proved notoriously difficult to print – the tables under the roof are underexposed because of the lack of light on this dark and stormy day – but it is this variation between light and dark that makes the photograph so magical.

Jubilee Street Party has been published many times since it was shot in 1977. Its first appearance was in the catalogue of the 1979 Hayward Gallery exhibition *Three Perspectives on Photography*, arguably one of the most important photographic shows of the decade. In this poorly printed catalogue, much of the picture's detail is obscure; the scene appears darker and more menacing than it would in subsequent publications, and its luminescence is almost entirely lost. The photograph next appeared as one of fifty-four illustrations in Parr's 1982 book *Bad Weather*. Though the back-cover text states that the photographs were taken with an underwater camera, *Jubilee Street Party* was made with conventional 35mm Leica equipment. In the notes to the book, Parr remembered his liking for 'situations in which people are

determined to do something, never mind the weather. I respect determination, it makes for intensity. In bad weather you can't be casual.'

The photograph appears again in *Home and Abroad* (1993), an anthology of colour images from Parr's major 1980s projects, including, *The Last Resort*, *The Cost of Living* and *Small World*. *Jubilee Street Party* appeared in the book at the request of author Ian McEwen, who had been commissioned by the publisher Jonathan Cape to write an introductory essay. Here he recalls buying the photograph from the Photographers' Gallery Print Room in 1977 with the fee he had received for a short story. He had never heard of Parr, but was immediately attracted to the sombre qualities of the photograph:

> Everything, the food, the plates and bowls, the tablecloths, is rain
> drenched. The road and pavements gleam with puddles. Rising
> in the background, behind the cake, are Victorian factory buildings
> picked out darkly against misty hills huddling beneath a stormy
> sky. There are no human figures in sight. Everyone has fled …
> A strong anecdotal quality reveals a muted moral point – or
> perhaps less a point, more a delicate shading; here, a rather rueful
> reflection on community, loyalty, and persistence in the face
> of an unkind climate.

Jubilee Street Party provides some important clues as to the direction Parr's work would take in the 1980s and 1990s. It shows his growing interest in food, a subject to which he first become drawn when he arrived in the North of England. Fresh from the Surrey suburbs, he discovered curry houses, corner shops and fish and chip shops. Throughout his career, he has been fascinated by this 'ordinary' food: communal buffets, café meals, cakes and jam displayed at fêtes and shows. He has consistently used food as a code to express his fascination with class and communality, returning repeatedly to the theme in bodies of work on consumerism, tourism and family relationships.

He senses and exploits a peculiarly British uneasiness with food, just as he senses our discomfort with travel, leisure and each other. This is evident in several works documenting the British eating in public, including his first serious photo essay, made in Harry Ramsden's fish and chip restaurant in Guisley while on a visit to his grandfather, the photographer George Parr. From photographs of finger food at the Conservative Party fête, to the consumption of fast food on the move, from an elderly couple staring past each other in a drab tea shop, to a crowd of raucous girls in a New Brighton chip shop, he has explored the comedy of manners that revolves around

food. Throughout the 1970s, he would return to places where the British ate together, to Butlins Holiday Camp in Filey (1972), to Manchester fish and chip shops, to the Mayor of Todmorden's inaugural banquet (1977) and, most famously, to the Boulderclough Methodist Chapel anniversary tea in West Yorkshire (1978). Brought up in a Methodist household, he was interested in frugality, and the church tea party – with its formal thrifty-ness and home-made refreshments – was a frequent subject.

Temporarily devoid of diners, *Jubilee Street Party* becomes a melancholy monument to the festivities associated with communal eating. Sombre, wistful and humble, it is typical of Parr's work on West Yorkshire. In the early 1980s he became disillusioned by the disappearance of the old-fashioned communality he had sought, and turned to colour photography. From then on, his photographs of eating and drinking centred around mass consumption, fast food and trash. While the West Yorkshire teas had been prepared with love and devotion, the food Parr now began to photograph had a ridiculousness, even grossness, which, to him, represented the disappear-ance of the kind of British society and values he respected so much. His love-hate relationship with British eating continues to this day, in his photo-graphs of pink icing pigs, wads of shiny sausages, dripping ice creams and glutinous burgers.

At the centre of *Jubilee Street Party* is a three-tiered, iced cake. This flamboyant object stands in stark contrast to the humble food that surrounds it, and the plain, industrial location of the party. The cake is a mystery, an anomaly, attractive to Parr, with his keen sense of the absurd and the inex-plicable. Without the cake, the photograph would have lacked a centre. It stands high above the plates of food, leading our gaze to the mill chimney, which, in turn, towers above the buildings that surround it, pointing upwards to the clearing sky. The correlation between these objects – two towers – brings grandeur to a simple scene. Wet surfaces are illuminated by the coming of light after the storm, everything glows, appearing to be fash-ioned from marble and granite, and a scene emerges that is dramatic, shining and filled with an almost biblical grandeur.

Through Parr's many photographs of celebratory meals during his years in the North of England, he honed a methodology that he would use again and again in the years to come. He proved that complex ideas about society and culture could be expressed through simple subject matter and the glimpsing of small ironies and visual comedies. *Jubilee Street Party* stands at the intersection between his fascination with people and a developing interest in still life, and demonstrates the ability of a single photograph to express a myriad of ideas.

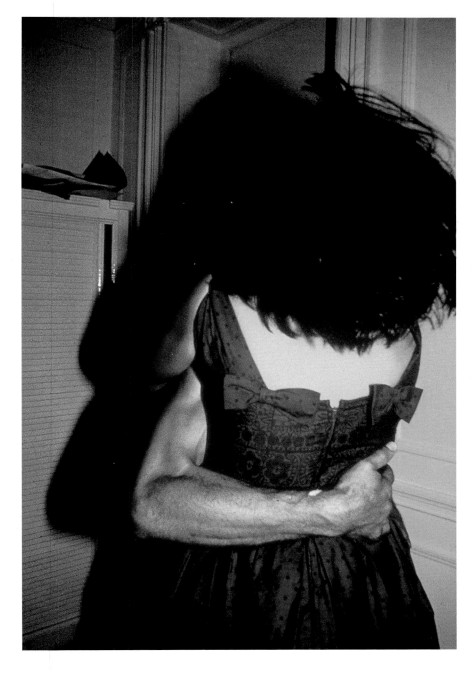

Nan Goldin
The Hug, New York City 1980

By Darsie Alexander

Human intimacy may be among the most difficult subjects to capture photographically, but for Nan Goldin it is the only subject. Throughout a career that began in the late 1970s, she has focused her camera on the personal relationships of her immediate peers, including her own friends and lovers. Sometimes this pursuit of intimacy-through-images seriously compromised those relationships. At other times it revealed them with extraordinary depth. The best of Goldin's photographs, like *The Hug, New York City*, share an ability to convey the complexities of love in extremely succinct terms, sparking endless speculation on the subjects' lives and destinies. Observing this couple pressed against each other in a secluded corner, we imagine what each person might have been seeing, feeling and thinking at the moment when Goldin released her shutter, blasting light into their space. Are they old friends or new lovers? Did they sense Goldin's approach and continue kissing for her benefit, or did they simply consider her too unimportant to break their embrace? At what point did these lovers become observers, matching the image against their memories? For better or worse, a camera locks even the most temporary relationships into permanence, capturing their momentary intensity with a decisive and intrusive click.

The encounter registered so powerfully in *The Hug* materialised in two distinct formats: as an individual print that has achieved a nearly iconic status in Goldin's oeuvre, and as a fleeting projection that appears toward the end of the artist's landmark slide work, *The Ballad of Sexual Dependency* 1979–96. (Remarks on this work are based on the version owned by the Whitney Museum of American Art, New York. Several others exist or are in progress.) Whether we experience the image as a still picture frozen against the page of a book or as an integral component of a broader slide-show narrative dramatically affects our perception of it. In the first instance, *The Hug* is a stable relic that can be retrieved from bookshelves or observed on gallery walls, accessible at any time for reference and analysis. Here the

act of viewing can be both intimate and prolonged, the fixity of the image depending entirely on the spectator's interest and time. The slide projection, however, is much more ephemeral. Most images last little more than four seconds before disappearing from the wall, providing but a brief glimpse for audience members. Moreover, the sequential format thwarts the desire to separate images, since each one gains meaning through cumulative effect, a blurring compounded by the rock-opera soundtrack with its mix of 1980s pop, club music and melancholic vocals. Beyond the way in which the slide show determines a particular form of spectatorship – one that requires sitting in a dark space for about forty-five minutes – the interplay of images and music also foregrounds transience, enhancing the effects of time's passage formally and thematically. In what follows, this tension between the stasis of a photographic object as a discrete container of information and the open, fluid qualities of *The Ballad* frame *The Hug* as both a singular and relational image – one with two distinct but interwoven lives.

As a stand-alone image, *The Hug* encapsulates the finite universe of two lovers whose lock seems unbreakable. It is not exactly an aggressive hold, but it is focused, with each person wrapping around the other in a move that suggests both passion and determination. The man's grip, visible from the front as he reaches around the woman's back, intensifies the picture's inward pull. There cannot be any space whatsoever between them; even her hair shrouds their faces as if protecting them from view. That their identities are unknown also heightens the picture's allure, especially given its concern with sexual intimacy. Though the facts of a blue patterned dress, a muscular arm, and a stack of papers sitting on a shelf are rendered with great clarity, virtually no details are given of the subjects themselves, though we long to know who they are and what they look like. Unlike other more explicit images, this one is deliberately circumspect, picturing a couple buried in each other's arms, shut off from the world. Yet the compactness of their forms and the composition, with its narrow margins and shallow space, do not convey restraint. Indeed, the picture implies the opposite – the thrill, possibility and danger of losing control.

Goldin amplifies the physical and psychological dimensions of *The Hug* by introducing a shadow to the left that almost swallows the lovers. On the one hand, this combined silhouette signifies their merger, and adds to the sense of their escape into a private space. On the other, it casts a pall over their moment, implying total self-annihilation. It is difficult to speak of shadows without using verbs that convey a sense of doom, since as entities they typically 'loom', 'haunt' and 'hover'. This shadow extends into the space of their bodies, creating a giant, black void around their heads,

suggesting lost consciousness as well as lost identity. Its darkness is particularly damaging to the wholeness of the man, rendering his arm a kind of clinging, disembodied appendage – an effect enhanced by what may be a small piece of white bandage on his wrist, perhaps covering a cut or wound. Severed from the outline of their arms, the shadow becomes a monstrous third person, a jagged profile with an extended nose and brow. Goldin has deliberately imposed the menacing effects of other presences, human and inanimate, on this couple.

She does this again by appearing in the picture herself, not as a person but as a glaring eye beating down on the couple with the light of the camera's flash. It hits the woman's back with drama and brutality, reminding us of how photography renders legitimate the act of staring at people, putting their most private encounters in the spotlight. Goldin has captured a moment of intimacy for thousands more to witness, strangers looking on for a variety of personal or artistic reasons. Here the light of the camera illuminates and divides, producing in its stage-like brilliance a kind of wall, a barrier separating those on view from the spectators. That this act of watching and capturing with a flash is the same gesture that produces the shadow is significant, for it purposefully links the threat that hovers around this couple with outsiders and voyeurs. Goldin may have taken the picture in a matter of seconds, but she knew that the flash would be bright, instantaneous and thematically powerful.

The Hug's dramatic lighting accentuates the female body in the composition. The woman's back, hair, clothes and shoulder control the plane of the image; even the arm stretched around her waist could function as an extension of herself, if imagined as a self-embrace. Her orientation also mirrors that of the photographer, a parallelism between the observer and observed that might be termed 'sympathetic', but the image also reveals a power dynamic – one that Goldin understood well from her personal as well as her artistic life. In romantic unions, even the most seemingly democratic, one person always slightly dominates the other. Throughout her work, Goldin notes the subtle and unavoidable imbalances that exist between couples, visible in their eye contact and body language. Significantly, the photographer's views rest heavily on women's experiences and perceptions. This may be an obvious by-product of greater access to the emotional lives of female subjects, but it also speaks to her highly subjective approach (she comments that she does not know how she feels about people until she photographs them). With *The Hug*, Goldin identifies the woman as the primary agent, the giver and receiver of the embrace, and the intended subject of romantic and photographic desire.

Goldin's scrutiny of coupling, evidenced in *The Hug*, drives the expansive narrative of *The Ballad of Sexual Dependency*, a 700-image slide work that explores the relations between love, power, addiction and death. Like many new arrivals to New York in the late 1970s, Goldin made her way as an artist by piecing together jobs in order to feed her work in photography. The circle she established in the city, including other artists, musicians and performers as well as drag queens and sex workers, granted her tremendous freedom with her camera. Their openness resulted in a body of work, shot largely on slide film, that privately documents and publicly asserts their passions and betrayals. When Goldin first created the slide shows, they were intended for this group of friends, lovers and peers, who showed up at bars, clubs and lofts around Manhattan to watch their lives unfold on screen. These events were famously chaotic and noisy, with people drinking, talking and laughing at one another as Goldin manually loaded and projected the slides. Often those in the audience were the photographer's primary subjects, and they both revelled in and chafed at how they looked in her pictures. Sometimes Goldin would remove sections or add in new images to reflect recent friendships, or cut people with whom she'd had a falling out or disagreement. This process of constant editing made *The Ballad* a deeply textured piece that responded directly to the circumstances of her daily existence – the comings and goings, break-ups and affairs. As life changed, the work changed.

The Ballad possesses an immediacy and ephemerality that mirrors the quick, intense moments that play out on screen: a woman grasps her neck as she laughs with aching pleasure; another takes a long drag of her cigarette; two friends – one with a black eye – embrace; a couple collapses on a bed after sex. Over time, these scenes build upon one another, as the sequences become more focused and the faces more familiar. Deep relationships are formed and personalities emerge. The woman with tears streaming down her face is the one in the shower later on. The laughing blonde gets married, her face solemn as rings are exchanged. We have the illusion of getting to know these people, seeing them in various states of happiness and distress. None, with the possible exception of Goldin's boyfriend Brian and her close friend Cookie Mueller, possesses a personal storyline with a conventional beginning, middle or end. However, *The Ballad* itself has an arc that is supported by loose sections that mark lines of development: couples, lovers and friends, women alone, women with each other, pregnant women, kids, women with guns, prostitutes, men being physical, men in beds, men with each other and with women, bars, drugs, nights out, couples hugging, couples in bed, more embraces, sex, passion, cupids, ceilings,

paired grave sites, empty beds, open caskets, painted skeletons kissing. Goldin's closeness to these subjects is often disarming and graphic. Yet the work also carries an urgent message about life and loss on a much grander scale.

Goldin establishes her narrative quickly with *The Ballad*. This story of gorgeous, youthful love is full of inward agony and externalised violence. Crucially, the slide show explores the connections between love and abuse, visible in the blackened eyes and bruised legs of bodies that have been punched, bitten and fucked. At the beginning of the work, couples abound in various states of contentedness and rapture: two bodies are seen distantly entwined on a park bench, an elderly couple touch on their doorstep. The next segment concentrating on women highlights their sensuality and vulnerability in mirrored reflections. However, the tenor abruptly changes when a scarred woman appears alongside the soundtrack's sobering lyrics: 'You didn't miss the girl, you hit the girl', emanating from the speakers. Later, another woman, head down, hugs herself in the dark. Through numerous self-portraits, Goldin becomes a part of this narrative, revealing to the camera a face full of wounds. The drive towards destruction picks up speed as the nuances between couples gain complexity. More images of people lying in bed, distracted from one another; more drinking, more shooting up. These are not shown with any degree of moralising, but the momentum is clear, moving like an accelerating car, to a tragic conclusion. *The Hug* is not fixed at this end point, but it is close enough to give form to final and lasting impressions.

When the picture finally arrives, it's a relief – an escape from these tensions. Bracketed by other images of people kissing and holding each other, it feels like the instantaneous consolidation of the most hopeful parts of *The Ballad* – its belief in youth and the full, uninhibited expression of sexual attraction and love. Sometimes this love looks tender, like the couple reading to one another in bed; at other times, it looks bizarre, as in the two gaping mouths reaching for contact. Throughout *The Ballad*, we gauge varying levels of intimacy and commitment, chemistry and defeat. We have seen innumerable hugs between longtime friends, parents, girlfriends and boyfriends. With an unsettling capacity to project mystery into every detail, Goldin records the nuanced language of people touching, suggesting through visible signs more subtle emotional interactions. As prints, most of these *Ballad* images are titled with the first names of participants. This picture is simply *The Hug*, a name that is also an action: a full-on embrace given without worries or fear or self-consciousness or pride. Slightly too strong to be a comfort-hug and too close to be the act of friends, the gesture

of this couple conveys both attraction and anticipation; it is the tight, expectant hug of beginnings, not endings. Indeed, in the sequence of images, the next picture shows another couple looking away from the camera, disrobed. The serial order, implying a narrative progression, is also iconographic: two embraces from behind, close up. The pairing is so strong, so memorable, that it subsumes certain elements noticeable in the still photographs. The shadow in *The Hug*, for example, serves as a compositional entity outlining the primary subjects more than as an ominous warning. What resounds is a backs-to-the-world embrace, the ultimate hug of togetherness and denial.

There was much for Goldin's friends and generation to turn away from. By the mid-1980s when *The Ballad* became a pre-recorded piece, the AIDS epidemic had taken hold on a personal level for Goldin as it ravaged her Lower East Side artistic milieu. Addictions and lovers came with a higher than expected price, and suddenly images from earlier years took on a different cast. Pictures of a youthful celebration became *memento mori*. A group of friends who had shared everything now shared a disease, while many either ignored it or saw it as form of punishment and retribution. Cookie Mueller, whom Goldin once described as a 'social light, a diva, a beauty, my idol', understood this right away when she was diagnosed, and gave Goldin a letter from a mutual friend, who viewed the response to the crisis as a witch hunt directed at free thinkers, agitators and those who were different – in short, everyone Goldin photographed. When Cookie died shortly after her husband in 1989, Goldin compiled images of her for the finale of *The Ballad*; one shows her body, arms crossed, lying in a casket. The soundtrack carries the emotions of these images forward – paired tombs, empty beds and blank walls. Sheila Hylton sings a reggae version of Sting's 'The Bed's Too Big Without You' (while *The Hug* makes its brief appearance), followed by 'Fais-moi mal Johnny', which accompanies images of couples in bed and ends with the tomb sequence. The first two tracks are fairly upbeat, with 'Fais-moi' rising to a racing, screaming pitch before Dean Martin's 'Memories Are Made of This' brings the pace solemnly back to earth. The last frame shows two painted skeletons groping each other in a final death-grip.

It is remarkable how many hugs run through *The Ballad* and Goldin's work in general, and how true they appear. People return to this almost primeval gesture again and again from birth to death: couples grasping for pleasure and sex or seeking comfort and stability among comings, goings and goodbyes. Melancholic emotions fill the screen, but so, too, does an irrepressible joy. There is little evidence of self-pity or regret about the

lives lived. For Goldin, the basic drive to be together is both the foundation of human experience and the reason for her photography. She takes pictures as if believing that her images will tell her something she doesn't already know about why people attach themselves to one another, sometimes to their peril. When she first took photographs for *The Ballad*, she could never have imagined that her subjects would become only pictures so soon. It seems impossible, given her subjects' energy and promise, that *The Ballad*, now twenty-five years old, has become a memorial, a way to hold on to the past that mirrors in the most transient, transparent terms, the fleeting lives it presents. Images surface and recede in memory as they do on the wall. *The Hug* stands out against myriad frames because it embodies so many moments and experiences simultaneously – not only the one between a couple reaching for one another in a dark corner, but also the one between the artist and her past. It celebrates those whose lives were too short, but whose time was spent together.

Hiroshi Sugimoto
Aegean Sea, Pilíon 1990

By Dominic Willsdon

Aegean Sea, Pilíon belongs to a series of more than forty seascapes that
Hiroshi Sugimoto has produced since 1980, at various locations around
the world. All the photographs have the same formula: they are shot in
black and white and the horizon between sea and sky divides the image
equally in two. The sea is always calm and the sky is always empty. There
are no boats, birds, aeroplanes or clouds (except sometimes some streaks
of white), no sun or rain, no humans, animals, machines or debris.
Nothing is happening and there is no suggestion of a future or past narra-
tive. Sugimoto has travelled to different places to produce essentially the
same image, but in a number of variations. Seen in groups of three or
more, as they are usually exhibited, it is these disciplined variations
between them that initially absorb us. The sea and sky have different
textures in each case; the tonal range is greater or smaller; the division
between the sea and sky is sharper or more blurred. It all depends on the
weather conditions. *Aegean Sea, Pilíon* is one of the most uniform and fine
grained because of the heavy mist that hangs over the scene. The horizon
has almost disappeared. Indeed, viewed from a metre away or closer, the
sea seems to blend imperceptibly into the sky, as if made from the same
substance, its texture becoming finer from bottom to top, where it is
indistinguishable from that of the paper.

Only these small, visible variations differentiate the seascapes. We can
make aesthetic but not geographical distinctions between them, until we
read the titles. These refer to the sea depicted and typically also to the
place from which the shot has been taken: *North Pacific Ocean, Stinson
Beach; Caribbean Sea, Jamaica; English Channel, Weston Cliff; Boden Sea,
Uttwil; Black Sea, Ozuluce; Sea of Japan, Rebun Island.* And as in songs,
place names evoke stories. Each image carries, through its title, a partic-
ular mix of the exotic and the familiar, myths and histories, politics and
leisure, associations that will be different for each of us depending on
where we are coming from and where we are going, the pictures we have

seen and the books we have read. Sugimoto is a Japanese photographer schooled in German philosophy at a university in Tokyo during the 1960s, and in Minimal and Conceptual art at the Art Centre in Pasadena in the 1970s, and who now lives between New York and Tokyo. He describes selecting his locations: 'I just open the map and then read the map carefully and the name of the sea is sometimes very interesting; it is a very important factor in this series. So I choose the name and then choose the location and then study the topological map very carefully.'

Sugimoto visited the Mount Pilíon peninsula in Thessaly, central Greece, for a few days during 1990, and took three very similar images, each of them in the daytime, which he included in the series. The one discussed here is in the Tate collection. It is a view of the Aegean Sea, looking east-north-east towards the coast of Anatolia, 150 miles away. Straight ahead, on the Anatolian coast, is the site of ancient Troy. If we could head there, and bear north-east, we would pass through the Dardanelles (the Hellespont), along the Gallipoli peninsula, towards the Bosphoros, Constantinople (for the Greeks) or Istanbul (for the Turks), into the Black Sea. Greek Macedonia, reaching round towards Thrace (now part of modern Turkey), is 150 miles to the north. The islands that separate the Aegean from the rest of the Mediterranean are roughly the same distance to the south. This is the dead centre of the Aegean Sea. From a European perspective, or at least from any perspective oriented, critically or otherwise, to what used to be called the 'European mind', no body of water in the world is as heavy with history and mythology. The Aegean is the stage on which the founding acts of European identity took place. It is the space in which a certain idea of Europe sought to define itself, especially in modern times, ever since the Romantics lauded Homer over the Roman Virgil and proclaimed ancient Greece the origin of culture. The Aegean separates Greece from Turkey, Europe from Asia. The mythic power and cultural significance of this place is dispersed through a hundred stories, from the time of *The Iliad* and *The Odyssey* to that of the European Union.

None of this is in the image, of course; it is merely called to mind because of the connotations of the title, the appeal of those stories, and the fact that there is nothing visible to suggest other, more prosaic narratives (no current realities: no container ships or windsurfers). In its blankness, *Aegean Sea, Pilíon* offers a screen onto which we Europeans, or those schooled in European thought, can project our reflections on our origins. The views from Weston Cliffs in Devon, England, or from Stinson Beach in Marin County, California, will conjure many stories for many people,

but not stories about origins, not in such a fundamental way. In this particular work there is a coupling of story and image that makes it exemplary among the series. Inasmuch as it alludes to the origins of culture, *Aegean Sea, Pilíon* relates to the strand of modern European art and literature that has taken the appeal of orgins as its theme; that is, Romanticism.

For the Romantics, the gap between Greece and Turkey is the original divide between the cultivated and the 'Barbarians', a term coined by the ancient Greeks to name those from the opposite shore whose language they could not understand; it just sounded like 'bar, bar, bar'. It is as if Europe is synonymous with culture, and culture exists when languages exist. Sugimoto has talked about the seascapes in general as a vision of a world undivided by languages.

Ah yes, the earliest human awareness ... To be aware of yourself
you have to separate from the world. When you name the things
around you – the sea, the air, etc – you separate yourself from
the world. The Legend of the Tower of Babel says that all human
beings once spoke the same language, but because we tried
to reach the divine, we were punished and our languages were
separated. My seascapes are before this happened ... they are
about our common awareness.

The earliest human awareness is a common awareness, he suggests, that is at one with the world. It is an awareness that is not exactly before language, but belongs to the Adamic language that (according to the legend in Genesis) we all shared and perhaps still do at some level. For Sugimoto, it is a language without names; because it is naming that separates us from the world and each other. To be aware of ourselves we name things, but because we each name things in our own language – Αιγαίον Πέλαγοςw, *Ege Denizi*, the Aegean Sea – naming creates difference, unintelligibility and distance. When God chose to punish humanity for daring to build a tower to reach heaven he divided us linguistically and geographically too: 'the Lord did there confound the language of all the earth, and from thence did the Lord scatter them abroad upon the face of all the earth' (Genesis 11). In his journeys across the face of all the earth, Sugimoto seems to be rediscovering an Adamic language, this time an aesthetic one. It is a Romantic theme: a belief in an aesthetic communion with nature, at the origins of culture, which also unites human beings; a sense that the possibility of that communion is somehow lost to us, but that both the belief and the loss can be communicated in art.

Aegean Sea, Pilíon is, then, some kind of Romantic work. But it is hard to tell what kind. In terms of its visual rhetoric, it recalls, more than anything, the meditative, lucid and meticulous landscapes of Caspar David Friedrich, and in particular, his *Monk by the Sea* 1809–10, one of the iconic images of Romantic landscape art. Friedrich's painting is also a view straight out to sea that omits any signs of specific place or time and therefore invites reflections of a higher order. It also shows a world divided into its most basic elements; this time there are three: sky, sea and land. A tiny figure of a monk stands on the shore, beholding the scene. Like other paintings by Friedrich, and like other Romantic works, it is an image of an encounter between nature and human being, the experience referred to by the now rather threadbare term 'the Sublime'. It is a theatrical and highly spiritualised moment. The unequal division of the elements – the horizon is low, the sky takes up four-fifths of the image – means that the sky imposes itself on the terrestrial world: it looms over the monk rather than resting at the horizon. The effect is enhanced by the inclusion of the human point of view in the picture, out there in the midst of the scene. In this drama Nature is also a character, an animus who responds to the human presence. The darkness over the horizon clears in the centre of the painting and what might be divine light shines through. It presents itself to the monk and to us, whom he represents. This is the event: the appearance into the world of nature's inner light and a devout man's communion with that light.

This theatrical idea of a spirit of nature animating the landscape passes from Romantic painting into strands of nature photography, not least in the work of Ansel Adams and the epic, even operatic landscape tradition of the American West (Friedrich and Adams are connected by the painters of the American Sublime, such as Frederic Church and Albert Bierstadt). In Adams's classic images of Yosemite, the drama depends on a number of elements: the detailing of tonal and textural contrasts across the surface of the landscape, which gives nature an expressive quality, as if it were representing thoughts and moods on its face; the composition of the image as a stage, with a proscenium arch created by mountains or trees, and a clearly articulated relationship between foreground, middle distance and background; and – related to that – the sense that the scene can be imaginatively occupied by human beings. In Adams's work, we see how the rhetoric of Romantic landscape tends, over time, towards the Picturesque – the function of the Picturesque being to humanise nature or, rather, to present it as being there for humans. Adams's achievement is to transfer the idea of the Romantic landscape into photography, so that its spirit seems like a fact of the world rather than a product of the imagination. Sugimoto has sought to

emulate Adams at a technical level – he uses a similar handmade, wooden 8 × 10 view camera to record maximum visual information – but he does not share Adams's aims: 'nature photography, like Ansel Adams, was booming in the late seventies. Technically, this kind of photography is very interesting, but as an art form it is very standard. There is nature in front of you and you happen to be a photographer, so why not take a beautiful picture? It is basically the concept of sightseeing.'

Despite having in common the elemental rhetoric of Friedrich's painting, and the technical bravura of Adams's photography, *Aegean Sea, Pilíon* is different in many other ways. Firstly, it is wholly undramatic. Unlike the stages of Friedrich and Adams, in which the relationships between component parts seem to wait for the possibility of a story, the space in the seascapes is uniform. The only relationship there is, between the sea and the sky, is static rather than dymanic. The sole element that skews the monotony of the composition, if it can even be called a composition, is the way in which the grooves that represent the waves are angled slightly away from the horizontal of the edges. Since there is no stage, there can be no encounter between man and nature. There is no event of any kind. It is hard even to see *Aegean Sea, Pilíon* as showing a moment in the daily cycle. We cannot tell whether the sun is going down or coming up, or whether the tide is coming in or going out. It is true that there are waves (events of a sort), and that the camera has picked them out with astonishing clarity, but they are not doing anything; there is no sense of the constant formation and dissolution that is the essence of waves. The photograph has stilled their motion at a particular moment and made them look as if they have never moved and never could. The surface of the sea resembles fake wood-grain surfacing for cheap furniture, or dead skin under a microscope. We cannot imagine anything living here. The scene seems embalmed. This is the second difference between Sugimoto's seascapes and the works of Friedrich and Adams: they present themselves as inert matter, like samples of minerals in Plexiglas boxes. Adams used the 8 × 10 view camera to make the landscape crackle with life, across a deep visual field, to give the impression that nature is possessed of a soul. Sugimoto uses it to record an empty, lifeless scene. In this respect the seascapes relate to two other photographic series he has made: the hyper-real wax museums and natural history dioramas in which animals, plants and humans – all dead or endangered – are rendered with a morbid degree of detail. The final difference is that unlike the landscapes of Friedrich and Adams (and Church and Bierstadt and others), Sugimoto's images have nothing to say about the spiritual value of the particular places they depict. Yosemite has a special spirit in

Adams's work. The repetitive monotony of the seascapes series dispels any belief in the uniqueness of these places.

Inheriting the Romantic tradition is a matter of working out what remains when the Sublime seems Picturesque, when spirituality offends our secular sense of human community, and when – in the age of scenic routes and designated areas of outstanding beauty – nature has become the object of sightseeing. The sober, self-aware Romanticism of *Aegean Sea, Pilíon* is one answer, and it is similar to that suggested by the monochrome painting. For a while, Romanticism lived on in the abstract painting that emerged at the beginning of the twentieth century, especially in the idea of the monochrome; in the early work of Piet Mondrian or Kasimir Malevich for example. The monochrome was modernist painting's attempt to preserve the spiritual content of Romanticism by abstracting it from its outer clothing, that is, from the rhetoric of landscape art. Sometimes the sea and sky were models, being naturally existing monochromes, as in Mondrian's *Pier and Ocean* series, *c.*1915. Advocates of the monochrome claimed it would mark a universal and revolutionary Year One of culture, laying the foundations for a new ecological aesthetics that would transform everyday life. *Aegean Sea, Pilíon* is close to the monochrome, conceptually, just as it is close to Friedrich's landscapes, rhetorically, and to Adams's photographs, technically. But unlike the monochrome, Sugimoto's image has no ethical content. It is like a performance of Romanticism from which the spirit has departed. It is an evasive work that plays various Romantic traditions off against one another. The fictional character of Friedrich counters the revelatory character of Adams. The mute and repetitive character of Mondrian counters the theatrics of Adams or Friedrich. Adams's attention to objective, visual facts and the necessarily representational nature of photography counters the inwardness of Mondrian. In the end, it operates like a complex vaccine: by giving us the Romantic in small, discrete doses, it inoculates us against everything about Romantic art that is no longer meaningful.

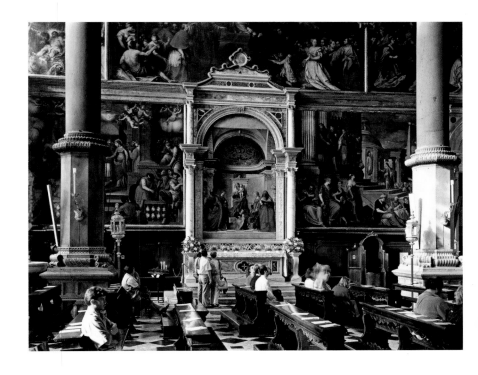

Thomas Struth
San Zaccaria, Venice 1995

By Sophie Howarth

A couple stand by the altar. He has a jacket over his shoulder, she a camera bag. They have come to look at the Bellini altarpiece for which the church of San Zaccaria is so well known. They have probably read that Bellini was nearly seventy-five when he painted the work and that he had been looking at Giorgione's paintings (which they too may have seen in the Accademia) and been trying to assimilate aspects of the older artist's style. Perhaps they are thinking how dignified Bellini's figures seem in comparison with those in the scenes by other artists all around.

In a pew just behind these two a woman has her hand to her mouth. She glances towards the small rack of candles to the left of the altarpiece, and seems deep in thought, or perhaps in prayer. I'd like to think this is her local church and that she often drops by to light a candle. She is probably used to all the tourists who come and go. Maybe she has noticed that they often stay inside longer during these summer months, escaping the heat.

The young man closer to us cuts a more ambiguous figure. Strong sunlight warms his back, but his body language remains cold. Although he looks directly ahead, towards the nave of the church, his thoughts seem inward facing. Only the saints in Bellini's painting match his sense of composure. Perhaps, like Jerome, he is a studious type, usually found with his head in a book.

A few rows in front, three visitors cast their glances upwards, relishing the abundant decor all around. And in front of them a woman accompanies two children, one of whom is perched on the back of the pew, rocking to and fro. No one queues for the confessional (whose empty shape echoes Bellini's painted architecture). But just above it are two more children, also a little fidgety. Elsewhere, we see a group of musicians, a host of angels, various saints and members of the nobility, numerous crowd figures, and of course the Madonna and Child, at the heart of the picture in every sense. There must be nearly a hundred figures in all, going about their different activities. Some of them have been here for centuries.

Thomas Struth was there for just four days in the summer of 1995. He had started making photographs of visitors in museums a few years before, and had made one in the Accademia in Venice in 1992. On this trip he wanted to photograph people admiring two well-known paintings in their original contexts: Titian's *Assumption of the Virgin* in the Frari Church and Bellini's altarpiece here in San Zaccaria. He was using a large-format camera, cumbersome but unrivalled in the detail it can capture. The camera uses 13 × 18 cm negatives, each of which must be carefully removed after it is exposed. Struth exposed approximately sixty negatives over the four days. There were only a few hours each day in which sufficient light streamed into the church for him to capture the detail in so many paintings. But the time around midday also provided him with a mix of people – tourists delaying their return to the heat and humidity outdoors and locals dropping by on their way home for siesta.

Why did Struth pick this particular image from his sixty or so negatives? To be sure, the composition centring on the Madonna and Child is balanced, and the light well distributed so that even very small details of both the architecture and the paintings can be observed in the final print. But two other things seem to me important about this particular photograph.

The first is the blur that results from the little girl rocking on the back of one of the pews while the camera's shutter was open. It is the one trace of real time in an image replete with painted illusion. While initially it serves as a reminder of reality, it also operates as evidence of the photographic impression. And just as it establishes the work's subtext as a study of the relationship between photography and painting, it also hints towards film, if understood in its most literal sense as photography in motion.

The second is the couple we began with. In the complex choreography of figures they are the only two who look at what we look at, that is to say, at Bellini's altarpiece. Everyone else is either absorbed in their own thoughts or looking 'off-screen'. If one tries to imagine for a moment viewing Struth's photograph in its intended setting of the museum rather than on the page of a book, the significance of what this couple are doing in relation what we are doing becomes more evident. They have come to admire the Bellini just as we have come to admire the Struth. Our act of looking incorporates their act of looking. And more importantly, Struth's act of representation incorporates Bellini's act of representation. So what we have is a set of relations between figures (us, tourists, saints, Madonna and Child) and between artistic media (film, photography, painting, architecture). Or more accurately, a set of relations between mediators and media since the tourists mediate our view

of the painting but traditionally the saints mediate between worshippers and the Holy Family.

This concept of mediation is particularly Catholic, as is the lavish approach to ecclesiastical decoration that San Zaccaria exemplifies. The church was originally designed in the Gothic style but completed in the later fifteenth century in a Renaissance style. Bellini was commissioned to create his altarpiece in 1505, and the paintings of New Testament scenes and contemporary papal ceremonies by Andrea Celesti, Antonia Zanchi and Antonio Vasillachi that surround it were added between 1600 and 1684. The final result typifies the visual extravagance, as well as the emphasis on the wealth and power of the Catholic Church, that so repelled the Reformers.

Struth accentuates this extravagance using all available technical and compositional means. He shoots at a time of day when light pours in from the back of the church, bouncing off the rich mahogany of the pews as well as the marble of the altarpiece and picking out accents of gold from the various sacramental ornaments. He uses a long exposure time to illuminate all the narrative detail and vibrant colours in the various panel paintings. He frames the central altarpiece, with its play on real and painted pillars, midway between two giant supports, lining up all the verticals to exaggerate the architectural echoes. And he treats the whole assembly of tourists, parishioners, saints, popes and angels like the cast of a vast opera, gathered in little groups, the colours of their costumes echoing across the stage. As our eye moves over the detailed surface of the photograph, we are continually drawn into architectural recesses or arrested by individual faces. In effect, Struth uses photography in much the same way that the Catholic Church once used painting – to tell stories, to enthrall and to transport us.

The paradox here is that photography is generally considered a medium of truth rather than faith. It is remarkable chiefly for its capacity to evidence what is real rather than illustrate what is believed. The Turin Shroud (a photograph of sorts) is celebrated precisely because it can be seen as direct evidence of Christ's mortality. But what status can we give to a photograph that shows a painted representation of holy figures?

Taken purely as evidence, the photograph shows a group of people who were in San Zaccaria at a particular time on a particular day in the summer of 1995. They are not spectacular, indeed in many ways they are less interesting than the painted figures surrounding them. But they are real; they were really there and this is really how they behaved. We can identify the central couple as tourists from their clothing and camera bag, and we can assume that they have come to this place because, at least to some extent, they have faith in the value of the art they will see there. This gives Struth's

photograph a strange status in relation to its medium: it provides us with *evidence* of a widespread *faith* in the value of art.

The belief of the Western world in the enduring value of its cultural masterpieces is explored across Struth's series of museum photographs. In the Louvre, the Pergamon, the Musée d'Orsay, the Art Institute of Chicago, the National Gallery, London, inside the Parthenon and outside Notre-Dame, he has set up his camera to document how individuals and groups behave around those artifacts or places we value most highly. This study of Western cultural behaviour is timely. Across Europe and America there has been a boom in museum building, which has in turn spawned critical discussion about the motivations for cultural tourism. Struth explains how the spectacle of visitors to one of the world's most popular art museums set him off on this particular project:

> I got the first idea in the Louvre around Christmas time; it was
> very crowded and I thought the … visitors in the Louvre, people
> of the most diverse ages and ethnicities, were incredibly similar
> to the themes in the paintings. And … I wondered: 'Why are the
> people there, what are they getting out of it, is any change
> occurring in their personal lives because of it, in their public lives,
> in their family, with their friends?'

He soon became interested in the way in which his photographs encouraged viewers to ask the same questions themselves. All his museum photographs are based around figurative paintings and he clearly sees the alignment of real and painted persons as crucial to their tautological success. Discussing the reception of an exhibition of the museum photographs in Venice in 1990, he said:

> I observed people as they went into the exhibition and how they
> reacted in amazement … Therein lies a moment of pause or of
> questioning. Because the viewers are reflected in their activity, they
> have to wonder what they themselves are doing at that moment.

Struth never shows us tourism at its most absurd. It is easy, we all know, to laugh at the camera-toting tourist, engrossed in his guidebook or sweating in his shorts. On occasion he exposes the charade of over-crowded destinations (the Stanze di Raffaelo in the Vatican for example), but he never mocks individuals. Indeed the visitors to San Zaccaria are typical in being depicted with dignity and a sense of the sincerity of their pursuit.

They are also typical in being allowed a level of privacy: we cannot see their faces, hear their conversation or know their thoughts (or prayers).

Of the fifty or so published photographs in the museum series, the works taken inside churches have a particular resonance because they set up a direct comparison between the faith people once had in the Church and the faith they now have in art. In the photograph mentioned earlier, taken in the Frari during the same summer as the San Zaccaria work, a group of seven people are shown, admiring Titian's *Assumption of the Virgin*. They are bathed in a shaft of light that enters the church from the eastern apse, and their slight movement during the slow exposure gives them a ghostliness suggesting that they, like the Virgin, are ascending to a higher realm. In the picture in San Zaccaria, the two tourists who look at the Bellini stand where thousands before them have stood, similarly expectant of being enlightened in some way. We do not need to know whether the Bellini has religious as well as cultural significance for them; either way, it has value as the affective medium.

It is easy to imagine a time not too far into the future when Struth's photograph of San Zaccaria will be looked on as a period-piece, providing evidence of the relaxed fashions of the 1990s, or the most advanced possibilities of photographic printing at that time (Struth uses a highly sophisticated technique in which the photograph is front-mounted onto the back of a clear acrylic sheet). It is harder to imagine how it might be looked on, if at all, in a few hundred years. Will people consider the late twentieth century's faith in art in much the same way that many of us consider faith in the Church today – as somewhat quaint, even a bit eccentric? Perhaps historians will look back on a time when cheap airlines meant a growing middle class could book the various legs of a Grand Tour or glean information about cultural artifacts in museums and churches across the globe at the click of a mouse. Perhaps they will look at Struth's work alongside press imagery of the crowds pouring into Tate Modern or the Guggenheim Bilbao and argue that this seems to have been a time when religion continued to be in decline (in Europe at least) but our belief in art was stronger than ever and cultural tourism a widespread form of leisure.

As I write, an exhibition of Struth's museum photographs has just opened in Oslo (hot on the heels of a mid-career retrospective that travelled to major galleries across America) and the second major book devoted exclusively to these works has recently been published. At a time when it has become so much easier for us to travel to cultural destinations across the globe, and to see great masterpieces in their original contexts, such keen interest in art presented in a photograph of itself may seem curious.

But the fascination of Struth's pictures is not, of course, with what they reproduce, but with what they document first hand. *San Zaccaria, Venice* shows us the social ritual of looking at (or just being around) a celebrated work of art and the almost-religious faith we put in that process. As in all matters of faith, it brings conformity and individuality head to head, inquiring into the value of appreciating what so many before us have appreciated. The couple by the altar stand where thousands have already stood, testing the capacity of Bellini's painting to move them. When we look at them we are looking at the *process* by which a civilisation comes to ingrain cultural value.

In his 1954 poem 'Church Going', Philip Larkin explores the 'awkward reverence' peculiar to visiting religious spaces in a predominantly secular age. The narrator is a passing cyclist who stops for a few moments and enters a small, empty church. After taking notice of all the usual paraphernalia – 'little books', a 'small neat organ', 'some brass and stuff / Up at the holy end' – he reflects:

the place was not worth stopping for.

Yet stop I did: in fact I often do,
And always end much at a loss like this,
Wondering what to look for

He struggles to make sense of why this rather unspectacular church seems to hold such significance for a 'bored, uninformed' non-believer like himself:

For, though I've no idea
What this accoutred frowsty barn is worth,
It pleases me to stand in silence here;

A serious house on serious earth it is,
In whose blent air all our compulsions meet,
Are recognised, and robed as destinies.
And that much never can be obsolete,
Since someone will forever be surprising
A hunger in himself to be more serious

San Zaccaria, Venice is a photograph showing a place where believers and non-believers alike are gathered, surprised by their common hunger

for something mysterious. Their compulsions and their desires are various, but they all wonder or are wondering under the same roof. When we see the photograph inside a museum it acts as a mirror to our cultural behavior, and, as always, we are quickly absorbed by our own reflection. In that moment of narcissism, the photograph speaks to us about the process of looking, about what we are looking for and where we look for it.

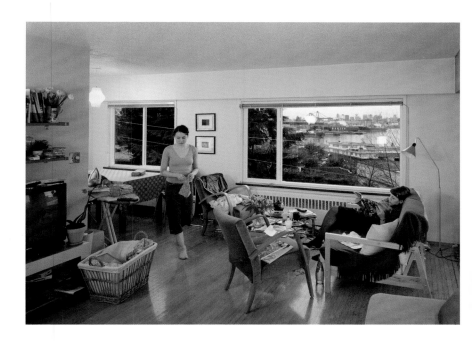

Jeff Wall
A view from an apartment 2004-5

By Sheena Wagstaff

Having driven me through a neat residential area set high above the timber depots and factory warehouses lining a busy Vancouver estuary, Jeff Wall parks outside a modest apartment block. On the second floor, he unlocks the door to reveal a small flat, its main room in comfortable disarray. The occupants seem to have just popped out, leaving behind the clutter and detritus associated with living in a small space. A lounge area with a blanket-draped sofa-bed, chairs and coffee table, littered with fashion and design magazines and half-finished drinks and plates of food, is adjacent to a small, clean dining area where two neat piles of napkins have been placed on an ironing board. The room offers a bright array of colours and textures, evocative of the restricted budget of a young person in the nascent stages of determining her own style. Dominating the scene is a breathtaking view through a large window. The estuary and surrounding topography, framed on either side by the green fringe of a fir tree and the skeletal branches of another tree, stretch back to the landscape's horizon, where the distant, jagged line of city skyscrapers delimit the scene like so many corporate sentinels to the land- and river-trade. Wall cautions me not to touch anything. We are, he tells me, standing in the set for *A view from an apartment*.

'The idea for *A view from an apartment* was to do an interior with an outside', he explained. 'But when you see the picture in its final form, you might be shocked by the way the exterior looks'. And on observing the completed image, I was indeed taken aback by the way in which he had calibrated to a jarring equivalence the light registers of the outside and inside scenes so that each would be simultaneously visible. I was also struck by the extent to which this work is a consummation of the complex notions around pictorialism and realism that Wall has explored for more than twenty-five years.

A view from an apartment suggests the quickening close of day, when the city lights in the distant vista take on an uncanny, sparkling brightness, and the lamps inside the apartment and in the dockside building beyond

have already been lit against the darkening of the winter evening. One of the young female occupants of the apartment is relaxing with a magazine, while the other is doing domestic chores. Crossing the floor past the ironing board from the table beyond, the latter emanates a graceful serenity as she looks over towards a carefully ironed pile of napkins. Her stance suggests a classical pose or a quote from a seventeenth-century Dutch or Spanish genre painting. Wall has said that he was not making portraits of these young women. Rather, he intended them to be characters, generic 'types' that we can easily recognise. Yet, the domestic touches – such as vases of flowers, clumsily framed modernist prints, the fact that the walking girl has been ironing – point to a more specific idea of the kind of person she represents. As is the case with many of Wall's pictures, the work's power lies partly in the faint suggestion of a narrative. The woman seems caught at a critical moment, possibly revealing something essential about the situation. The fact that the two girls do not communicate with each other implies either the quiet, easy relationship between friends who are comfortable in each other's company or that there is an unspoken tension between them. The latter interpretation is strengthened by the way in which the seated woman slumps into the corner of the sofa, possibly in a position of mute defiance.

It is in the nature of Wall's work, however, that this scene does not record a single moment in time, but is created by digitally combining and adjusting a multitude of photographic images shot at different times and in different locations over a long period. Since the 1990s, he has relied on computers to form a seamless montage of images, blending the documentary aspect of photography with artifice and performance to create realistic, 'probable' scenes. He has a painter's concern with composition, volume, colour, texture and perspective, which he uses to expand photography's technical and pictorial capabilities. Thus, in *A view from an apartment*, what appears to be an ordinary domestic scene is in fact a completely staged scenario.

To find his protagonists, Wall advertised in the local paper for 'stylish young women in their twenties'. He then gave one of the girls a small budget with which to decorate the apartment by sourcing furniture and other objects from thrift stores or Ikea, and allowed both to choose the clothes in which they were photographed. To shoot the young woman moving without the faintest blur of movement, all daylight had to be replaced by flash. A massive covered scaffold was erected outside the apartment block, which enclosed the second-floor flat for a month. Having boxed it in, an internal walkway was made around the apartment, creating something akin to a film set inside.

Wall fashions a moment in the life of ordinary people, a commonplace scene that functions as a quiet iconography of modern life. Its tranquil mood is illuminated and emphasised via the strange quality of the light, an incandescent, optical brilliance masquerading as daylight that limns each detail of the domestic clutter, creating a ravishing patchwork of sumptuous colours and textures. In its wealth of variations it evokes the precision of an abstract pictorial surface, but it is almost baroque in its plenitude. Wall's delight in exploring the sensually descriptive potential of photography is evident.

The topographical view depicted through the main window is a 'straight photograph' of an urban landscape that Wall has long regarded as a documentary foundation around which he could build a more complex tableau. In classic reportage style it shows Vancouver's distant cityscape and mid-distance docklands as a series of successive zones of modern commerce. Wall has often spoken fondly of Vancouver as 'not an impressive but very ordinary city', adding, 'that is what modernity is like when it is fresh'. Despite my glimpse of the Vancouver suburb in which *A view from an apartment* is set, the picture is clearly intended to be read as alluding to any twentieth-century city. 'In my pictures', he explains, 'I try to perceive … the actual environment in which we live, as the result of all our labours and errors. One of the essential things about the vernacular is that it is unimpressive, it is ordinary, worse than ordinary. It is the essential phenomenon of what we call "the new".'

Wall has talked of the power of the idea of ordinariness – ordinary architecture, people wearing everyday clothes, a pictorial vocabulary that is inconspicuously normal – to express the drama of human life both subversively and profoundly. The obsessive, almost claustrophobically close attentiveness to ordinary things in *A view from an apartment*, and the enhanced brightness and impossible sharpness of detail, are reminiscent of a film by David Lynch in which the uncanny lighting of mundane suburbia hints at mysterious stories beyond the surface. The intensity of the upright girl's stance supports this sense of strangeness.

There is also a sense of ambiguity in the reflection of two white lights on the window pane. We cannot detect their source with any degree of certainty, but it is not hard to imagine that they relate to other lamps in the apartment, or are the result of the lighting used to take the photograph. Either way, they are outside our immediate field of vision but are nonetheless part of the place of the picture. On closer inspection, we can see that they have a kind of afterimage, a double judder of silhouetted light, which, when lined up along their respective edges, indicates a vanishing point just

outside the window. If we are to understand that the reflections cause the window to act as a mirror, this would mean that the lamps that have created them are spatially located in the place in which we stand, or indeed – if the picture is understood as the result of one careful shot – the very place where the camera might have been set up. The effect of this is to implicate us directly in the picture, locating us in a third spatial register that is an invisible but essential extension of the image we see. We are at the threshold of another zone, poised between the visible and the invisible, between what is in the field of view and what is 'out of shot'. In establishing his picture's autonomy using a series of spatial relations between mirrors and reflections, Wall adopts a markedly similar formula to Velásquez in his famous work *Las Meninas* 1656.

Wall has spoken often of his discovery of Velásquez and Goya, on his first visit to the Madrid Prado in 1977, as a major watershed for his art. He realised that the combination of scale and complex spatial orders in Velásquez's monumental portrait, *Las Meninas*, of the Spanish royal family and their attendants, causes us to move back and forth when looking at it. We view it from different distances and angles in an effort to work out the profound mysteries of the picture, especially in relation to its reflected mirror images. Such an experience – almost like dancing in front of the picture – is also engendered by *A view from an apartment*. Both works suggest that there is no fixed way to see a picture.

Like Velásquez, Wall also uses the picture within a picture device to increase our consciousness about where we stand, both spatially and intellectually, in relation to the scene depicted. In *A view from an apartment* the position of the exterior landscape and the interior domestic scenes relative to each other is implied not only by the perspectival relationship but also by the windowpane between them. The windowpane is important because it echoes the threshold at which we find ourselves in front of the work, looking into and through the frame of the photograph to the fictional but believable world that Wall has set up. At this point the word 'view' loses its significance as a noun and becomes a verb. Neither of the young women in the picture is looking at the view from the apartment: we are. Indeed, as the window flickers at its constantly shifting threshold between outside and inside, and briefly silvers over to become a mirror, it reveals the third space in which we stand. Thus we are conceptually seeing a reflection of ourselves looking at the view. In a fleeting instant, the work offers us both a view from an apartment and a view of ourselves.

Wall has given another reason for his revelation at the Prado: 'I was struck to see to what extent all those pictures were contemporary. *Las Meninas* was

not a thing of the past; the picture was there, in the contemporary environment, in the world. I was looking at it, in the present.' He likened Velásquez's painting to a sculpture by the Minimalist artist Carl Andre, because both concentrated on the relationship of the artwork to the viewer's body. By showing his large-scale photographs as lightboxes, Wall echoes Minimalism's sculptural techniques, creating a sense of present time and present space, and in doing so making particular phenomenal demands on the viewer. *A view from an apartment* consists of a huge transparency mounted on an aluminium display case and illuminated from within by fluorescent tubes, evoking what Wall describes as 'a sense of enhanced life, as well as the sparkle and shimmer of real light'. Jutting out from the wall and hung just off the ground, the lightbox insists on its status as discrete object, whilst also offering up a pictorial image of depth and light. We can easily feel that the ground on which we stand could be an extension of the floor that the almost life-sized young woman is crossing within this enormous illuminated object. Yet as she approaches us, her eyes seem deliberately averted from recognising our presence. Despite drawing us into his pictorial structure, Wall ultimately insists on a face-off.

Wall is insistent that his pictures do not emerge from an uncritical return to the past, but rather result from his curiosity about the extent to which the Western pictorial tradition is still vital. He is also intent on preserving a relationship with traditional documentary by mixing it progressively with what he calls 'cinematography', that is to say staged photography. His works can be seen as combining elements of both cultural traditions. As in neo-documentary cinema or television, Wall employs a mixture of camera work, natural settings, non-professional actors and stage direction. His aim is to balance the frozen and artificial treatment of large-scale scenes associated with the history of painting, with the fluency of modern photography. Beyond this, what preoccupies him is the precariousness of the pictorial structure, both in its fragile projection of illusion, and in how far he can push the allegorical and extra-spatial potential of photography. Through his painstakingly controlled mastery of his medium, he encourages us to accept the illusion of his realism. He is concerned to heighten our understanding, to provoke us into 'seeing' what the image reveals – and also what it conceals. *A view from an apartment* holds all these intentions in an extraordinary state of equivalence and tension.

Notes on Contributors

Sophie Howarth is a Curator in the Interpretation and Education department at Tate Modern.

Darsie Alexander is Curator of Prints, Drawings and Photographs at the Baltimore Museum of Art.

Geoffrey Batchen is Professor of the History of Photography, Contemporary Art, and Cyberculture at CUNY, New York.

David Campany is Reader in History and Theory of Photography at the University of Westminster.

Roger Hargreaves is Founding Editor of the *International Journal of Photography and Culture* (forthcoming from Sage).

Liz Jobey is Associate Editor of *Granta* magazine.

Mary Warner Marien is Professor of History of Photography and Theory at Syracuse University.

Sheena Wagstaff is Chief Curator at Tate Modern.

Nigel Warburton is Senior Lecturer in Philosophy at the Open University.

Val Williams is Director of the Research Centre for Photography and the Archive, University of the Arts London, London College of Communication

Dominic Willsdon is Leanne and George Roberts Curator of Education and Public Programmes at the San Francisco Museum of Modern Art.

Details of Illustrated Works

William Henry Fox Talbot
Latticed Window
(with the Camera Obscura),
August 1835 1835
Photogenic drawing negative
3.6 × 2.8 (1⅜ × 1⅛)
Collection of the National
Museum of Photography, Film
and Television, Bradford
Photo: NMPFT/Science and Society
Picture Library

Charles Nègre
Chimney Sweeps Walking 1852
Albumen print,
after a wax-paper negative
15.9 × 21.7 (6¼ × 8½)
Private Collection
Photo: Sotheby's Picture
Library, London

Julia Margaret Cameron
Iago, Study from an Italian 1867
Albumen print
33.4 × 24.8 (13⅛ × 9¾)
Collection of the National
Museum of Photography, Film
and Television, Bradford
Photo: © NMPFT/Science and
Society Picture Library

Man Ray and Marcel Duchamp
Dust Breeding 1920
(printed c.1967)
Gelatin silver print
23.9 × 30.4 (9⁷⁄₁₆ × 12)
The Metropolitan Museum of Art,
New York. Purchase, Photography
in the Fine Arts Gift, 1969
Copyright: © DACS, London 2005
Photo: © The Metropolitan
Museum of Art, New York

Bill Brandt
A Snicket, Halifax 1937
(printed 1948)
Gelatin silver print
20.3 × 25.4 (8 × 10)
Copyright: © Bill Brandt Archive
Photo: Bill Brandt Archive

Diane Arbus
A young Brooklyn family going for a
Sunday outing, N.Y.C. 1966
Gelatin silver print
50.8 × 40.6 (20 × 16)
Copyright © Estate of Diane
Arbus, LLC 1966
Photo: Courtesy Robert Miller
Gallery, New York

Martin Parr
Jubilee Street Party, Elland,
Yorkshire 1977
Black and white fibre print
30.5 × 22.9 image on
40.6 × 30.5 paper
(12 × 9 on 16 × 12)
Copyright: © the artist and
Magnum Photos
Photo: Courtesy Magnum Photos

Nan Goldin
The Hug, New York City 1980
Cibachrome print
101.6 × 76.2 (40 × 30)
Copyright: © Courtesy the artist
and Matthew Marks Gallery,
New York, and Jay Jopling,
London
Photo: Courtesy the artist and
Matthew Marks Gallery, New York

Hiroshi Sugimoto
Aegean Sea, Pilíon 1990
Black and white photograph
42.2 × 54.2 (16⅝ × 21⅜)
Tate
Copyright: © Courtesy the artist
and Sonnabend Gallery, New York
Photo: Tate Photography

Thomas Struth
San Zaccaria, Venice 1995
Chromogenic print
182 × 230.5 (71⅝ × 90¾)
Courtesy the artist and Marian
Goodman Gallery, New York
Copyright: © Courtesy the artist
and Marian Goodman Gallery,
New York

Jeff Wall
A view from an apartment
2004–5
Transparency in lightbox
167 × 244 (65¾ × 96)
Copyright: © The artist
Photo: Courtesy the artist

Dimensions are given in centimetres,
followed by inches in brackets